STEAMPUNK LEGO®

The Illustrated Researches of
Various Fantastical Devices by Sir Herbert Jobson,
with Epistles to the Crown, Her Majesty Queen Victoria;
A Travelogue in 11 Chapters

BY GUY HIMBER

no starch
press

Steampunk LEGO®. Copyright © 2015 by Guy Himber.

First printing

Printed in China

18 17 16 15 14 1 2 3 4 5 6 7 8 9

ISBN-10: 1-59327-528-5
ISBN-13: 978-1-59327-528-0

Publisher: William Pollock
Production Editor: Serena Yang
Jacket Design: Sylvain Amacher *(http://www.facebook.com/captainsmog/)*
Interior Design Concept: Chris Gould
Developmental Editor: Riley Hoffman
Copyeditor: Paula L. Fleming
Compositors: Ryan Byarlay, Laurel Chun, and Serena Yang
Proofreader: Alison Law

For information on distribution, translations, or bulk sales, please contact No Starch Press, Inc. directly:
No Starch Press, Inc.
245 8th Street, San Francisco, CA 94103
phone: 415.863.9900; info@nostarch.com;
http://www.nostarch.com/

Library of Congress Cataloging-in-Publication Data

Himber, Guy, 1965-
 Steampunk LEGO : the illustrated researches of various fantastical devices by Sir Herbert
Jobson, with epistles to the Crown, Her Majesty Queen Victoria / Guy Himber.
 pages cm
 ISBN 978-1-59327-528-0 (hardback) -- ISBN 1-59327-528-5 ()
 1. LEGO toys 2. Steampunk fiction. 3. Steampunk culture. I. Title.
 TS2301.T7H55 2014
 688.7'25--dc23

 2014013785

To the memory of Herb Jobson,
the original Steampunk

ACKNOWLEDGMENTS

I'd like to thank V.P. Himber for his support, enthusiasm, and love of the bricks.

Thanks also to Serena Yang and Riley Hoffman of No Starch Press for their infinite patience, understanding, and mad publishing skills; and to Bill Pollock for publishing this book and so many other great books about LEGO.

To the LEGO Steampunk community, especially Rod Gillies and Sylvain Amacher, and to all the other amazing LEGO AFOLs: it has been my pleasure to meet you all and share in your contagious passion for the infinite possibilities of little plastic bricks. This book couldn't have happened without the generosity of your talents and wit.

CONTENTS

What Is Steampunk? . vii

Rolling Stock. 2

Monowheels and Penny-Farthings.22

Horseless Carriages .38

Robots and Automatons.64

Armaments and Sundries82

Cabinet of Curiosities100

Seven Seas. .110

Airships and Dirigibles.130

Clockwork Beasties. .154

Floating Rocks. .166

SPACE! .176

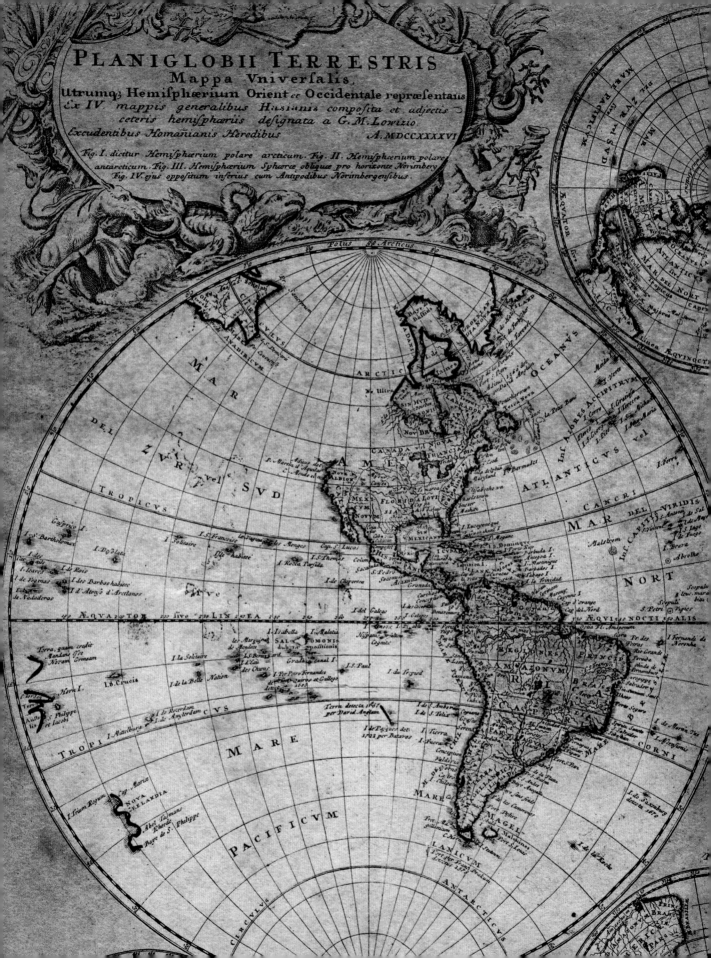

PLANIGLOBII TERRESTRIS
Mappa Universalis,
Utrumq; Hemisphærium Orient et Occidentale repræsentans
ex IV. mappis generalibus Hasianis composita et adjectis
ceteris hemisphæriis designata a G. M. Lowizio.
Excudentibus Homañianis Hæredibus A. MDCCXXXXVI.

Fig. I. dicitur Hemisphærium polare arcticum. Fig. II. Hemisphærium polare
antarcticum. Fig. III. Hemisphærium Sphæræ obliquæ pro horizonte Norimbergæ
Fig. IV. ejus oppositum inferius cum Antipodibus Norimbergensibus.

MAPPE-MONDE,
qui represente les deux Hemispheres, savoir
celui de l'Orient et celui de l'Occident, tirée des
quatre Cartes generales de feu M. le Professeur Halius,
dressée par M. G. M. Lowitz et publiée par les Heritiers de
Homann. p 4. 1746

WHAT IS STEAMPUNK?

Steampunk is a creative genre that imagines an alternate history of 19th-century technology. Its devotees employ a fanciful blend of fantasy, science fiction, and historical adventure to tell their stories. Electricity has just started to enter the realm of the common inventor, but steam-powered machines are the tools of the day. Clockwork gears and mechanisms are often exposed for ease of service and ease of appreciation. Daring inventors float through the skies and roam the countryside in their fantastic contraptions.

The artists, authors, and filmmakers who work in the Steampunk genre value independence, creativity, and whimsy—which makes LEGO a perfect embodiment of the Steampunk philosophy. LEGO builders don't want mass-produced, generic things but tools from which we can build our own unique ideas and creations.

Within these well-worn pages you will find an extensive collection of the world's greatest Steampunk builders and the wonders they have created. Page after page of mechanical marvels and scientific mysteries await you, intrepid reader! Top up the oil in your lamp, put on your favorite goggles and top hat, and let's explore!

Yours in Steampunkery,
Guy Himber
V&A Steamworks

SIR HERBERT JOBSON

Sir Herbert Jobson is a trusted and highly regarded member of Queen Victoria's royal entourage. The Queen has seen fit to honour him with knighthood in the Most Distinguished Order of Fanciful Devices and appoint him to the post of Queen's Chronicler of Technology. In this capacity, he ventures around the world and reports on exciting developments in the Sciences and their potential for civilian and military applications. His military know-how and seasoned diplomatic *savoir faire* serve him well as he compiles this "Domesday Book" of scientific wonders.

Lt. Penfold

With his typewriter ever at the ready, Lieutenant V.P. Penfold is the loyal and tenacious aide-de-camp of Sir Herbert. Commissioned from the Queen's Guard after his exemplary bookkeeping skills helped turn the tide of the Crimean War, Lt. Penfold serves faithfully as both scribe and dogsbody, chronicling Sir Herbert's sometimes questionable commentary and offering occasional tidbits of advice and tempered guidance. Possessed of a nimble mind and a voracious appetite for knowledge, he is renowned for his exceptional wombat stew.

If you come into possession of this journal, it means that I have fallen at the hands of a dastardly plot. Whatever the circumstance, you are commanded to pry this book from my cold, dead fingers and take it posthaste to Her Majesty, Queen Victoria. Rest assured that you shall be compensated handsomely for this service.

Sir Herbert Jobson

Most Distinguished
Order of Fanciful Devices,
Queen's Chronicler of Technology

21. March

Aboard the Edison's Bane—admiring the copper wires

Your Majesty,

The kingdom's railway system stretches outward like a vast
network of veins and arteries, and London is the thundering
brave-heart that pumps commerce inward and outward,
serving the needs of England and the Commonwealth.
One day I hope Your Majesty might join me for a jolly
good day of "trainspotting," a newly invented sport, wherein
a group of curious observers might settle down by the rail
yards and enjoy the splendour of the ever-changing "parade
of locomotives."

Steam-powered freight engines pull an endless stream of
railroad cars, coaches, and wagons of every imaginable size,
colour, and purpose.

A small sampling of these grand machines follows.

Yours in service,

Sir Herbert

ROLLING STOCK

POST CARD

THIS SPACE FOR ADDRESS ONLY

PLACE STAMP HERE

"The introduction of so powerful an agent as steam to a carriage on wheels will make a great change in the situation of man."
—Thomas Jefferson, 1802

MODEL 7244 BY TONY SAVA

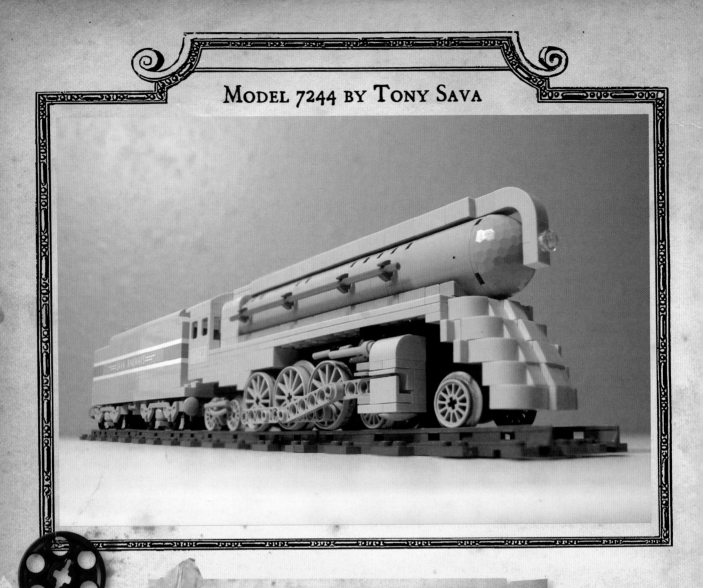

This groundbreaking design comes from
Captain Sava, the Aggie of Yorktown.
Working closely with his young engineering
protégé, Colburn, Captain Sava created this grand
superpowered steam locomotive as the first in a
proposed series of what he calls "Hudson-class"
engines. I think we have an early favourite
for next year's transcontinental race!

POST CARD

THIS SPACE FOR ADDRESS ONLY

PLACE
STAMP
HERE

A philosophical battle is being waged for the future of steam-powered electrical engines. This prototype locomotive is a first step in an effort to convert steam power into alternating electrical current to achieve a more effective and efficient use of energy. AC is the future!

EDISON'S BANE
BY V&A STEAMWORKS

CORNWALL CANNONBALL
By Ted Andes

CANNONBALL

Pilot: Cyrus Bane

POST CARD

CORRESPONDENCE ADDRESS ONLY

R LONDON 3739
No. 43

The Cannonball is a small, speedy, and utilitarian locomotive designed by the Cornwall Ironworks as a courier transport. It got the nickname "cannonball" because it is designed to explode upon impact with enemy railships (or anything else, unfortunately). This is also why the pilot is seated to the side—to more easily eject just prior to an imminent collision.

It is no surprise that they are now quite popular with the very best delivery services!

Lt. Penfold

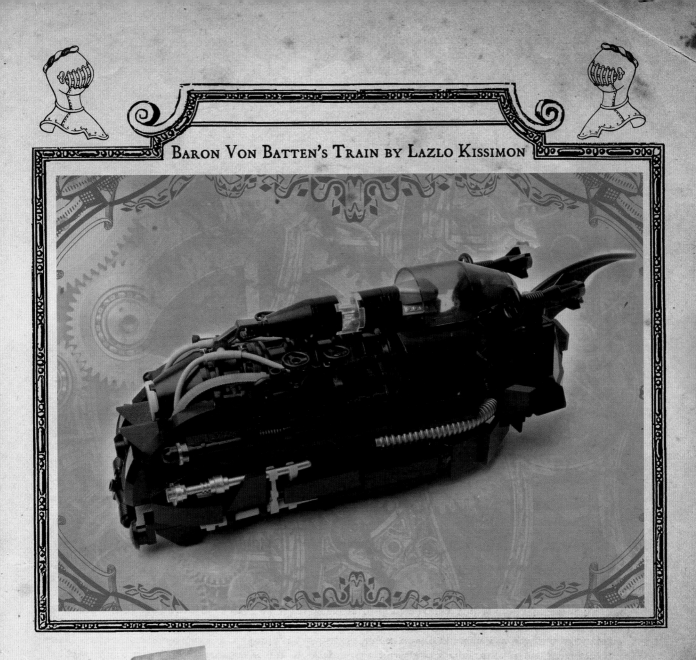

Legends abound about the mad millionaire Baron Von Batten, who claims to have travelled from the future and somehow become trapped in our own time. If true, this lunacy may explain his peculiar obsession with bats.

This engine was crafted by a few who believe the time traveller's story and have a fondness for madmen's money. In the hands of this self-appointed vigilante of the rails, this high-pressure roller is ready to confront any dark forces at play upon our nation's railways.

CLOCKWERK EXPRESS
BY FELIX HERZBERG

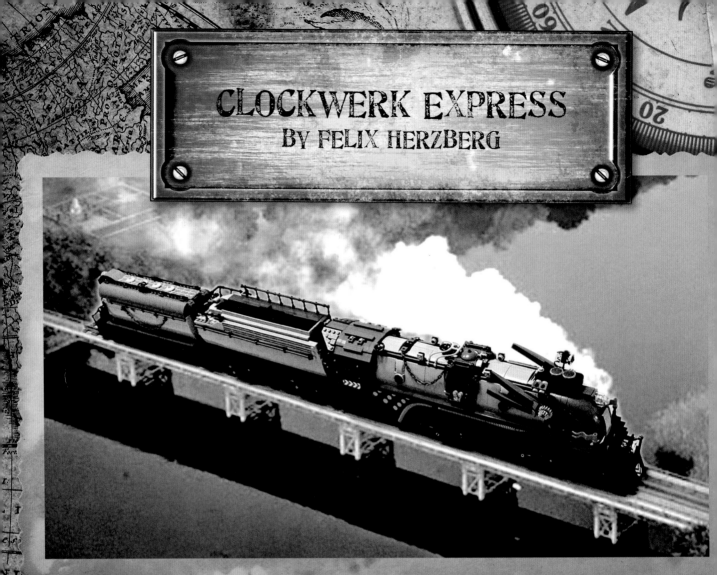

Your Majesty's current favour for rail travel has helped keep your Royal Engineers in constant pursuit of faster and safer steam engines. The enthusiastic boom for more efficient trains has resulted in this splendid engine. It is equipped with two tenders, one for coal and one for water, and a mighty quadruplex drive powers four Mountain Hammer XL motors. Your subjects have grown to love travel by these splendid excursion trains as they roll along the tracks to popular destinations, such as temperance gatherings and afternoon tea ceremonies.

Fig. III
8

CATCHING ROCKS
BY FELIX HERZBERG

A vessel for true explorers, Catching Rocks boasts an onboard dirigible for scouting beyond the train's most lamentable limitation: the track. Initially designed as a purely exploratory vessel, it was later outfitted with grand seine nets and put into service to help collect the various small particles of Cavorite detritus that have recently collected over the skies in the north end of Britain.

POSTAGE
ONE PENNY

These underwater adventuresses are as marvelous as their conveyance. When they're not chugging down the transatlantic railways finding treasure, hunting a bounty, or saving a gentleman in distress, they can most often be found relaxing in the panoramawagon that's towed behind this distinguished scarlet engine.

DIVING BELLES
BY DREW ELLIS

NEWCOMB'S FOLLY
BY TED ANDES

In this image, we see Admiral Newcomb pictured along with his "Quorum of Legendary Oddfellows" (from left): Oscar the Automaton, Sir Arthur Conan Doyle, Annie Oakley, and "Stinky Pete."

Lt. Penfold

Admiral Simon Newcomb's Amphibious Dynamotive Exploratorium, more commonly known as "Newcomb's Folly," was invented when Newcomb determined to create an amphibious locomotive transport for his astronomical and electro-physical expeditions—this despite everyone saying that it was a fool's errand. The true folly was in the original model's inability to handle the curves on many railways. As a result, Newcomb had to make a concession and separate the hull into two sections, then reconnect them prior to a water launch. Due to the inevitable leakage at the joint, the Folly's amphibious ability was generally limited to short river and lake crossings.

RAILCASTLE DEFENDER ENGINE BY PASCAL SCHMIDT

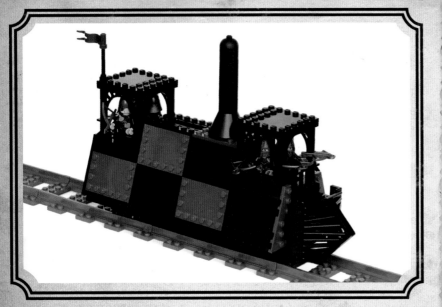

Near the white cliffs of Dover, a "fleet" of scurvy "pirates" ride the Queen's rails in search of treasure and fortune. To combat these miscreants, German mercenaries have been commissioned to patrol the area in the heavily armoured Railcastle Defender Engine.

Thick steel plating allows the Railcastle Defender Engine to roll into the heaviest of artillery fire and ward off even the most aggressive assaults.

MARK IV SELF-PROPELLED ARTILLERY BY PASCAL SCHMIDT

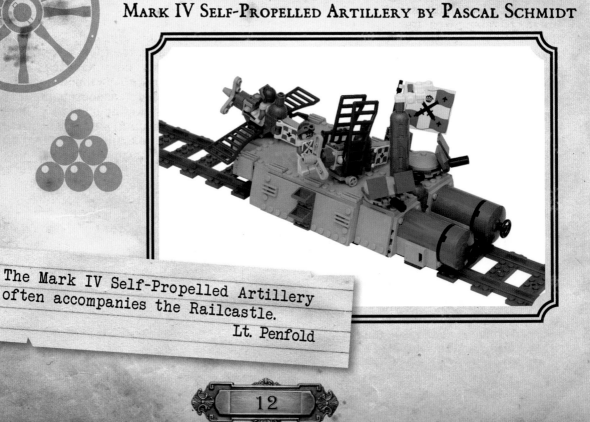

The Mark IV Self-Propelled Artillery often accompanies the Railcastle.
Lt. Penfold

PIRATE RAIL
BY PASCAL SCHMIDT

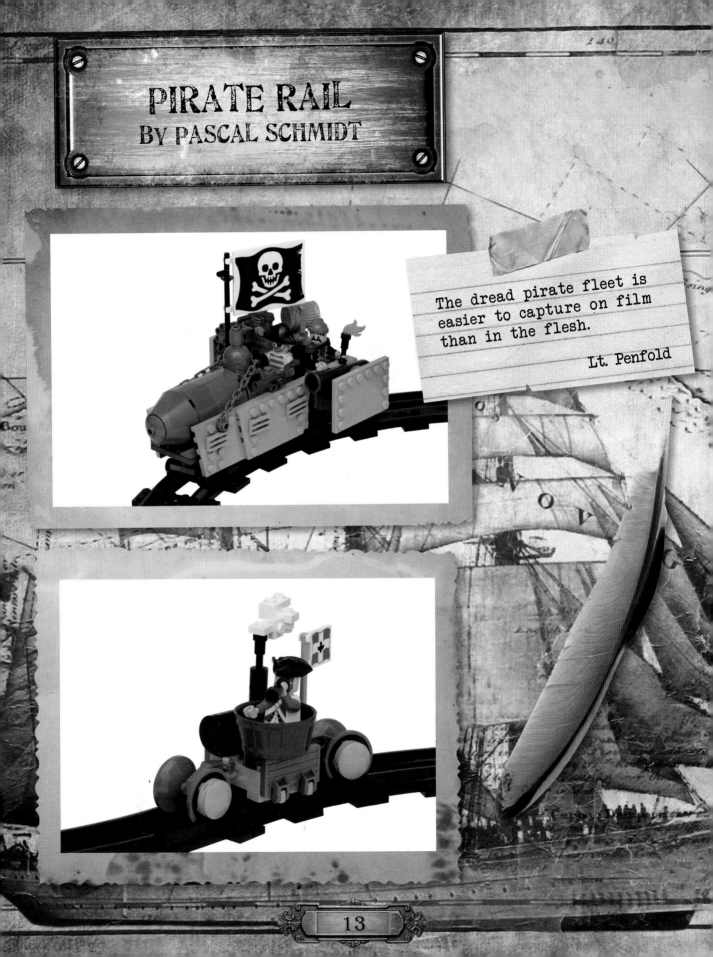

The dread pirate fleet is easier to capture on film than in the flesh.

Lt. Penfold

URBAN STEAM MONORAIL
BY CAPTAIN SMOG MANUFACTORY

SWISS

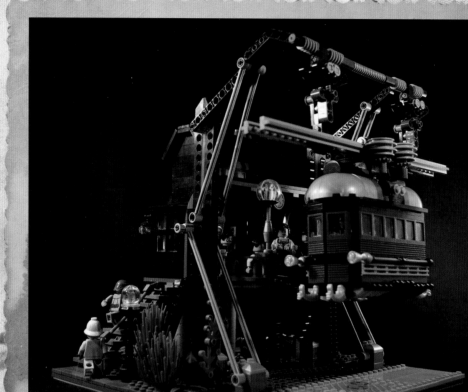

The Corps of Royal Engineers is hotly debating the future of public rail transport—will it lie in the space above our heads or beneath or feet? While some argue the value of drilling giant holes in the ground and filling them with a cold and dark underground railway, more sunny-minded thinkers envision a world of fresh air, with luxurious cars gliding high above the cobblestone streets.

Fear of Giant Moles?

Lt. Penfold

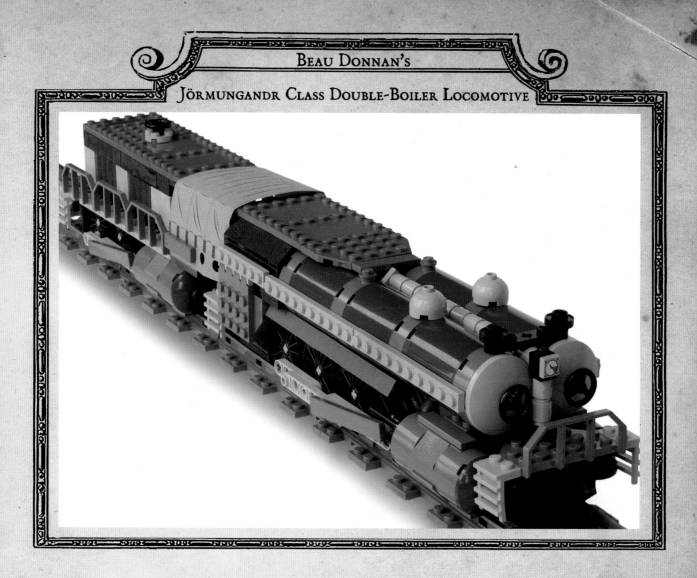

POSTAGE DUE 5d

This twin-boiler steam engine with a powered tender car is typically used to haul freight. In times of battle, however, it can be used to transport troops and cargo to the front lines and can also be plated in armour and used as an improvised railship.

LIGHT STEAM LANDSHIP
BY BEAU DONNAN

The Light Steam Landship is capable of speeds unheard-of for its size, thanks to its twin boilers, and formidable firepower in the form of a heavy cannon and two light turret guns. Unlike conventional tracked vehicles, this agile landship is able to maintain a high top speed even while turning, due to its innovative "bogie tracks" that swivel when changing direction.

"ARMADA-CLASS" HEAVY STEAM RAILSHIP
BY BEAU DONNAN

Essentially a heavily modified version of the world-famous Dreadnought design, the Armada Class boasts many clever improvements, such as two compressed air—powered lifeboats that can deploy to adjacent tracks on either side of the ship. The Armada Class also features two naval anchors, which can be dropped to act as an emergency braking measure. In total, the Armada is armed with three medium cannon turrets, four automatic rifles, and a quadruple-barrelled anti-aircraft turret.

"Shunter-Class" Light Steam Railtug
by Beau Donnan

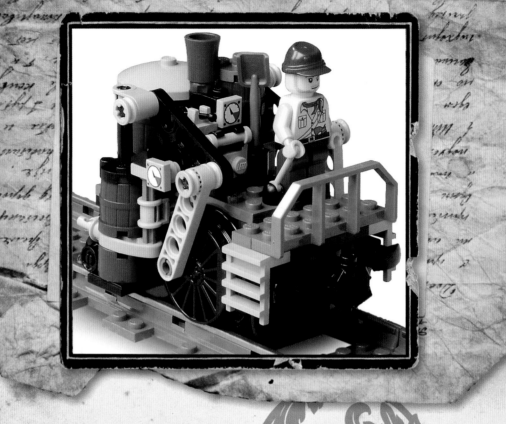

This rail yard shunter uses a large and powerful military-grade boiler to power its two massive pistons, which must be mounted horizontally and connected to the drive wheels via beams due to the compact chassis. These small yet strong railtugs are also commonly used as "slave engines" to augment the pulling power of freight locomotives.

"Ironclad-Class" Light Double-Gauge Steam Railship
by Beau Donnan

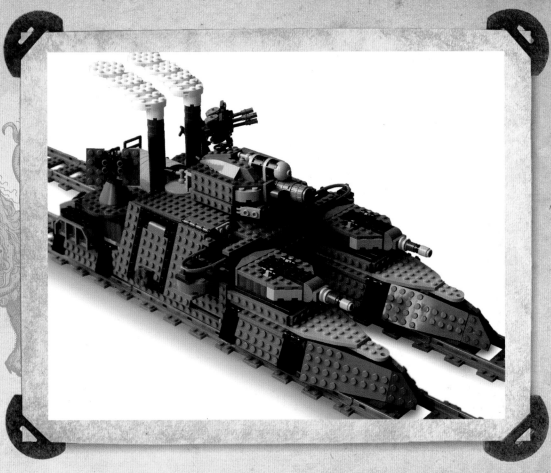

The Ironclad Class is armed with two forward-mounted medium cannon turrets, one heavy howitzer turret, two rear-mounted quadruple-barrelled anti-aircraft cannon turrets, and two automatic rifle mounts on the platforms. This gigantic railship moves on two separate tracks so as to support its hulking mass and to create a low centre of gravity to balance the recoil of its powerful cannon.

Developed in the American colonies and adapted from the mechanized prairie schooners that carried settlers across the vast western frontier, the Light Steam Transport Vehicle is highly versatile and exceptionally reliable. This lightweight vehicle sports wide treads to navigate sand, swamps, and other inhospitable terrain. The crew consists of a driver, a stoker, and up to five passengers.

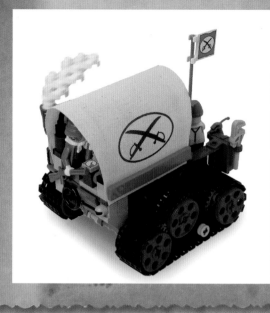

Light Steam Transport Vehicle
by Beau Donnan

Far Eastern Light Steam Tank
by Beau Donnan

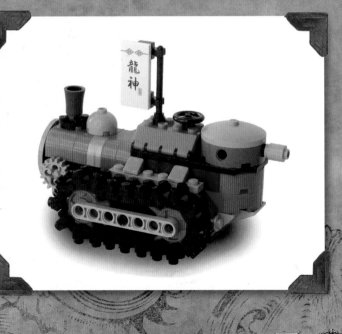

This vibrantly painted vehicle forms the backbone of many Far Eastern armoured companies. Its strong boiler propels it at great speeds, making it an agile unit on the battlefield that can easily outmanoeuvre its opponents and catch the enemy in a vulnerable position. It is armed with a light cannon and equipped with large treads to traverse difficult terrain.

BEAU DONNAN'S

"TITAN-CLASS" DOUBLE-BOILER LOCOMOTIVE

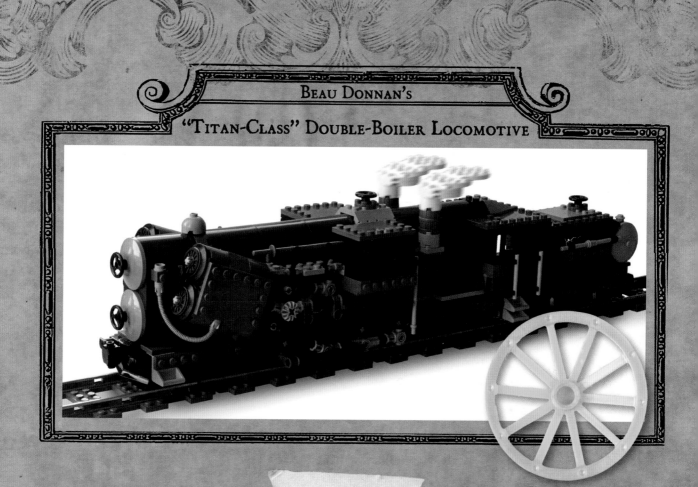

The Titan's boilers are twice as large as those of its
little brother, the Jörmungandr, and are mounted in an
over-under configuration. Designed for wartime usage
near the front lines, the Titan boasts special mounts
above the valve gears for armour plating to protect the
vulnerable machinery.

10. April

Eaton Cottage Hospital, Ward 8—having wounds tended to

Your Majesty,

By sitting within a single great wheel, one is afforded all of the
splendour of a traditional buggy without the troublesome bother
of the other three wheels. The great outer ring is usually driven
by a series of smaller wheels, and a steam-powered motor can be
installed to propel these fanciful roadsters forward.

These one-wheeled, single-track vehicles control both speed
and direction with the same apparatus, thus eliminating the need
for extraneous steering linkages and cumbersome safety features
such as the ability to view oncoming hazards. I should note that
reliable principles such as foot-dragging and leaning are proven
techniques to which no amount of technology will ever be proven
superior.

The ~~wheels~~ wheel of Progress never stops its deliberate spin...

Yours in service,

Sir Herbert

P.S. I have also included noteworthy accomplishments within
the field of bicyclery, which has thus far proven to be a 100 percent
improvement upon unicyclery.

MONOWHEELS AND PENNY-FARTHINGS

PENNY-FARTHING
BY V&A STEAMWORKS

Before contributing noteworthy developments to the design of horse-drawn monowheels and other "doughnut" craft, the wizards at V&A Steamworks mastered the art of the classic Penny-Farthing. It is recommended that riders place their feet over the handlebars when going downhill at high speeds to allay somewhat the chances of lethal injury.

Here we see a member of the League of British Wheelmen riding a Penny-Farthing.

Lt. Penfold

THE VELOCICHOPPER
BY KARF OOHLU

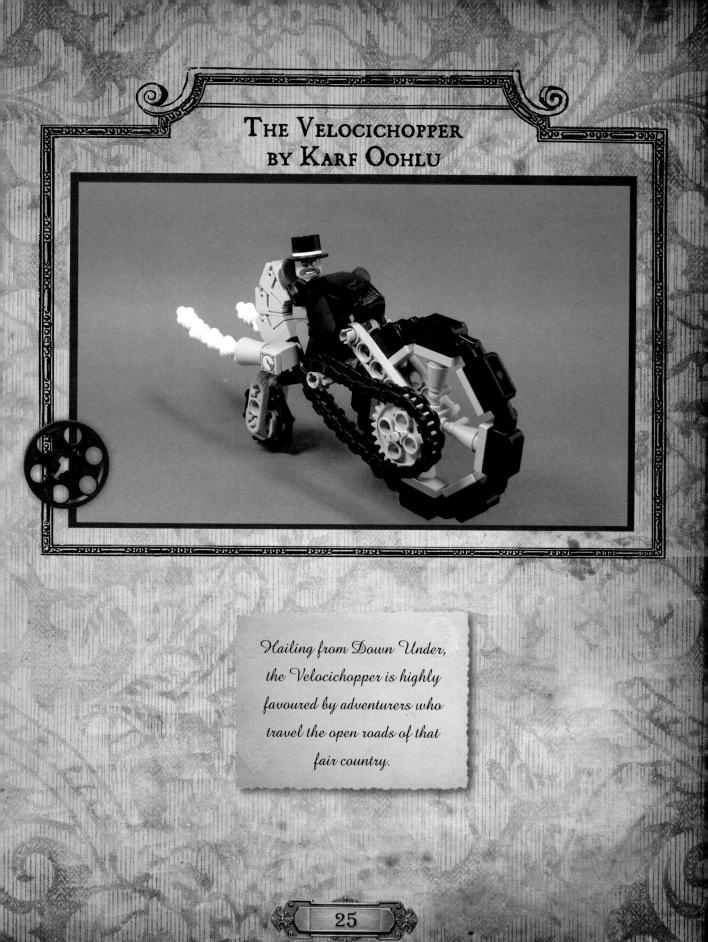

Hailing from Down Under, the Velocichopper is highly favoured by adventurers who travel the open roads of that fair country.

AMERICAN ZEPHYR
BY ROD GILLIES

The famous "American Zephyr" is the most popular model in the 2MC range of Davis & Harleyson mechanized bicycles. The large front wheel design allows for high speeds and daring deeds. Though this is verily a difficult and dangerous machine to operate, riders scoff at the risk of "taking a header." The newly rubberized wheel system eases the Zephyr over ruts and furrows and takes the sting out of cobblestone roadways.

DOCTOR HIGHTOWER'S PERSONAL ENGINE
BY ROD GILLIES

Available from selected shops for self-assembly at home.

Noted as one of the most luxurious and gentlemanly monowheel vehicles, the D.H.P.E. features elegant craftsmanship and the first-ever reclining chair. Burled hardwoods and durable leather upholstery more than make up for a certain absence of visibility.

R.A.C.E.R.
BY DAN SABATH

I was made most welcome at Rusty Clank Manor, the home of Rear Admiral Daniel "Kiyose" Sabath, now retired. Admiral Sabath is an early innovator of mono ideals and Victorian sciences. He pioneered the very first forms of monowheel design by carefully ignoring such incidental problems as the wheel's inability to stop, obstruction of the view of oncoming hazards, and poor stability.

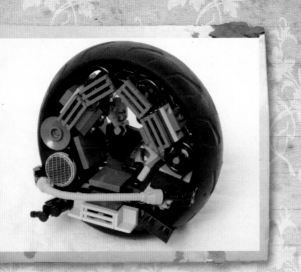

The Admiral has always been guided by his belief that a true man ignores such petty dangers! I salute this great figure whom so many have come to know as the Father of the Contemporary Monowheel.

STEAMCYCLE
BY ERIC CACIOPPO

A hybrid of designs by James Starley and Frenchman Eugene Meyer, this "Man Slicer" uses wire-spoked tension wheels to achieve revolutionary speeds and mustache handlebars to achieve impeccable style!

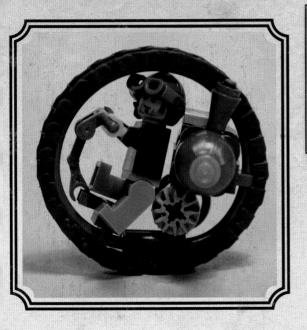

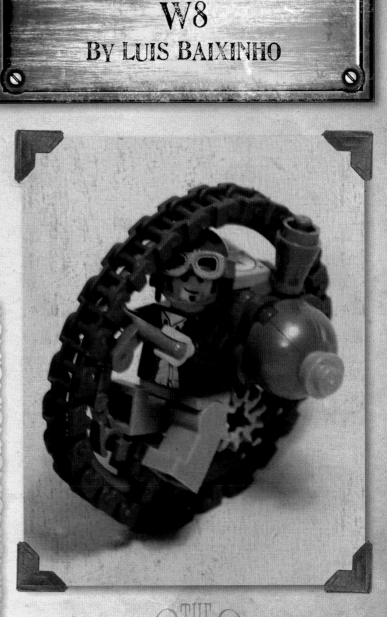

The W8 Monowheel has become a popular vehicle for dreamily touring about the English countryside. The characteristic main rim is surrounded by a dependable caterpillar tread. This track is driven via a small high-capacity steam engine that allows for exceptional vehicle speeds. For years, illegal W8 races have been a rite of passage among the young nobility. Despite the dubious reputation conferred upon the W8 by these young rebels, its most common use remains as a reliable wheel for carefree jaunts along country lanes.

THE ORIGINAL PRODUCT

ROYAL STEAMONOTRACK
BY PASCAL SCHMIDT

The Royal Steamonotracks are instantly recognizable due to their eye-catching Prussian blue colour scheme and flawlessly outfitted pilots. Only a select few of the Queen's guards survive the rigorous elite training program and are deemed worthy of captaining one of these distinctive wheels.

SWISS MADE

DER GOLIATH
BY CAPTAIN SMOG MANUFACTORY

Dr. von Shrapnell's "Der Goliath" is the largest Monowheel ever created. This most impressive weapon features an armoured exterior equipped with two steamolite ray-cannons and space for as many as four crew members. Certainly this ringed brute is not the most nimble, yet its shortcomings in manoeuvrability are more than compensated for by its splendid appearance and capacity for high-speed travel.

I have been told it can maintain speeds in excess of 49 miles per hour!
Lt. Penfold

STEAMONOWHEEL
BY CAPTAIN SMOG MANUFACTORY

POST **B** CARD

CORRESPONDENCE ADDRESS ONLY

domestic
one penny
foreign
three pence

Though currently Earth-bound, the Steamonowheel is being developed for use by British soldiers who must one day fight in the great Martian Wars of the future!

I believe this is what we
would call "putting the
cart before the horse!"

Lt. Penfold

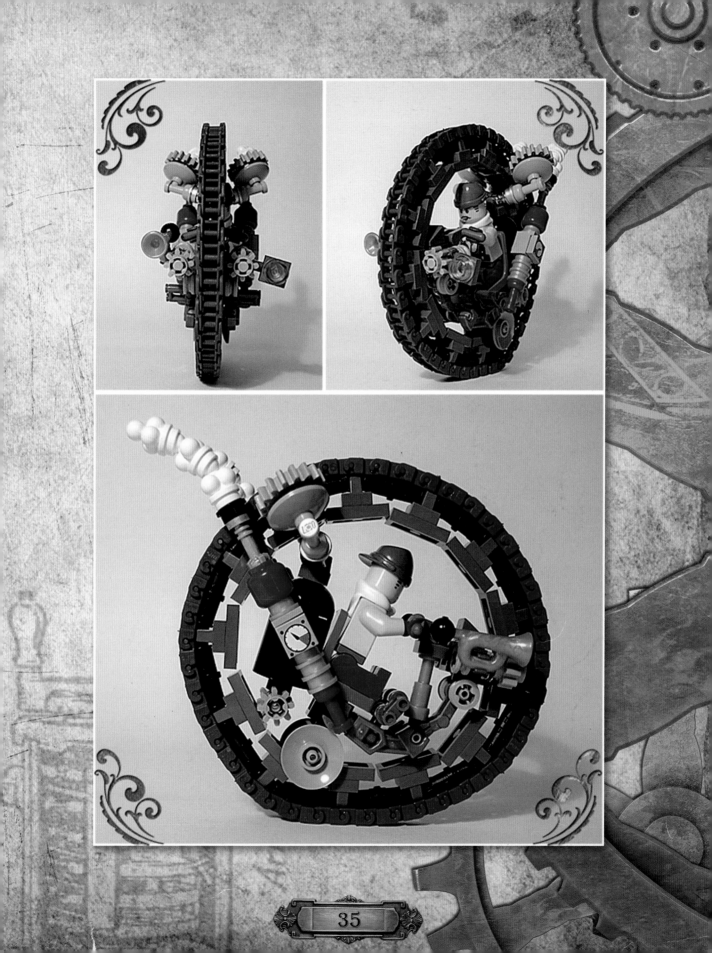

THE FIVE POINTS WHEEL BY BRIAN RINKER

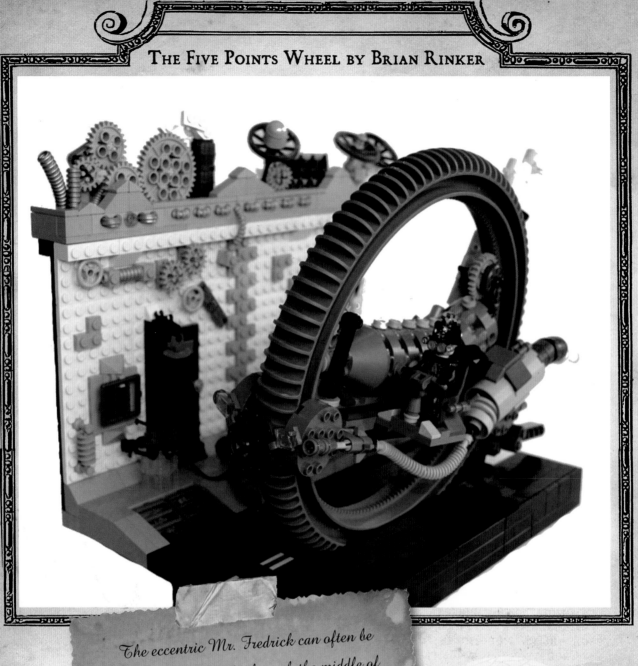

The eccentric Mr. Fredrick can often be seen taking a joyride through the middle of New York, past the infamous Five Points, to the great surprise of the pedestrians on the sidewalk. Noteworthy community leader Bill Cutting has nicknamed this jolly disc the "Wheel of Fortune."

NELSON YRIZARRY PRESENTS...

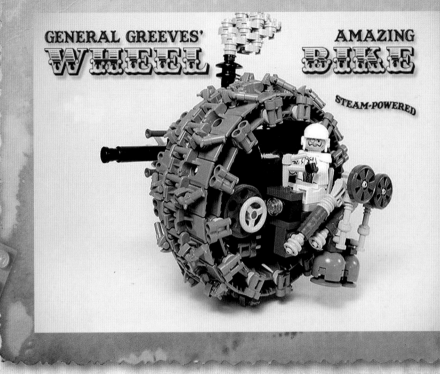

GENERAL GREEVES' **WHEEL** AMAZING **BIKE**

STEAM-POWERED

Upon donning a crash helmet, General Greeves is capable of unimaginable manoeuvres in this remarkable machine. Early design issues caused the driver to spin around the inside of the ring like a gerbil in a hamster wheel—a most undignified occurrence— but adjustments to the acceleration and braking apparatuses have almost entirely put a stop to that.

16. May

Crawler Town — touring the gardens

My Queen,

To quote the renowned Literary Digest, "The ordinary 'horseless carriage' is at present a luxury for the wealthy; and although its price will probably fall in the future, it will never, of course, come into as common use as the bicycle."

These steam-powered coaches with their armoured steel and wooden frames feature the latest in leaf springs and sliding-gear transmissions. What does that mean in practical terms? Forgive me, Your Majesty, but no more horse shovels!

Yours in service,

Sir Herbert

HORSELESS CARRIAGES

POST CARD

THIS SPACE FOR ADDRESS ONLY

PLACE STAMP HERE

THIS SPACE

"Because I could not stop for Death,
He kindly stopped for me;
The Carriage held but just Ourselves
And Immortality."
—Emily Dickinson

Von Bentlee by Lazlo Kissimon

Wealthy entrepreneur and bon vivant Drador Bentlee built this highly embellished vehicle. After earning copious profits through his breadfruit-importing firm, Bentlee turned his attentions to creating the most decadent and luxurious craft ever constructed. Unhampered by budget or common sense, the Von Bentlee has become a symbol of "flash" over substance. Catcalls accompanied the maiden voyage of the Von Bentlee as it rolled pompously down King's Road this past winter.

The Worthington and Smith (W&S for short) is renowned throughout the Empire for its many modern innovations. Features such as the monotube steam generator, the automated water-feed controller, and the low-pressure boiler make the W&S an appealing option for the novice driver.

HEDGEHOG
BY PIOTR RYBAK

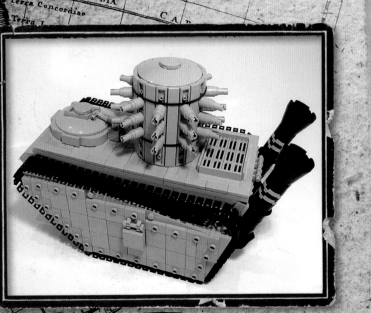

The hardy, aptly named "Hedgehog" moves forward via the recently popularized tread system, and the frame is joined to heavy-duty springs and rear-facing exhaust pipes. The "Hog" can traverse the most challenging of obstacles to deliver a thunderous volley of over 50 cannons firing in unison!

Fig. III

STEAMIKOMA
By Théo Bonner

This four-legged walker can easily traverse any irregular surface, even the worst ruts and bumpiest cobblestones. Whenever the fire needs coal, however, the driver must stop the machine and descend from the seat to access the rear boiler and refuel.

MACHINE NO. 1 BY VINCENT GACHOD

This horseless carriage, which one might term an "all-terrain vehicle," represents a remarkable step in modern innovation. Foregoing traditional building materials, its builder has outfitted it with finely hammered Tin fenders painted a luminous Paris Green. Though sleek, this rowdy upstart will have to prove itself functional without proper gears, rivets, and beams.

Sir, there seem to be some worrisome reports that the Paris Green paint is also useful as a Rodenticide!

Lt. Penfold

VINCENT GACHOD'S T6-CLANKER

This mechanized, multilegged war machine is piloted by a crew of five—commonly called Brass Soldiers. The Clanker is armed with defence against Zeppelins in mind, with twin Rampage .45 caliber Gatling guns and a Black Powder–class forward cannon.

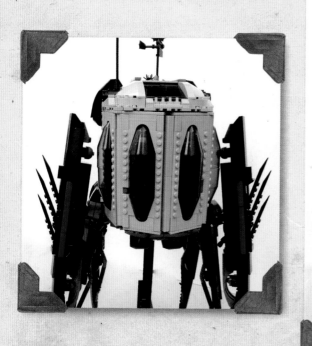

CRAWLER TOWN AND SALTY TOWN
BY DAVE DEGOBBI

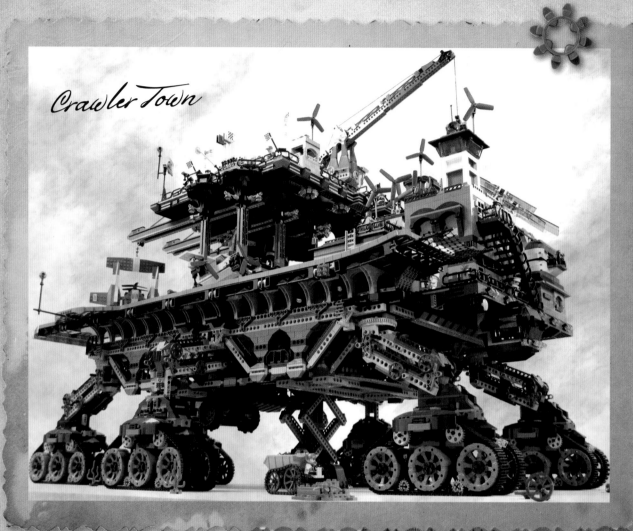

Crawler Town

A variety of working cranes, elevators, shops,
and living quarters gives Crawler Town
a pleasingly industrious appearance.
It features a full grandstand on the top level
for viewing its famous Aero 500 races.

Many journey to Crawler Town to vacation or trade for fresh vegetables and beer. This bustling mobile town traverses the countryside in search of underground mineral supplies and fresh water. Talk to any inhabitant, and you will hear a compelling tale of the community's self-sufficiency.

This roving hamlet has bred an environmentally conscious society that covers its habitation with sun energy jars, wind-spun electric motors, water traps, and hanging vegetable gardens.

Salty Town

In contrast to Crawler Town we find the scurrilous hive of Salty Town. Home to a disreputable band of sinister pirates, the small city scouts the open plains in search of smaller, poorly defended British villages to pillage and plunder.

KRIEGERHUND BY JAMIE SPENCER

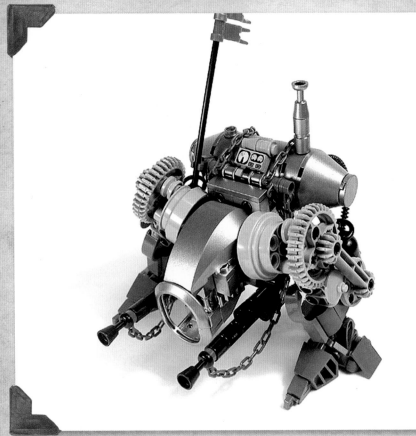

As we face the double-edged sword of our rapidly expanding Empire, this fearsome unmanned war machine, the Kriegerhund, may be the answer to our labour challenges. We might one day deploy these vigilant electrical chaps to quell our enemies far and wide.

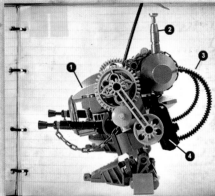
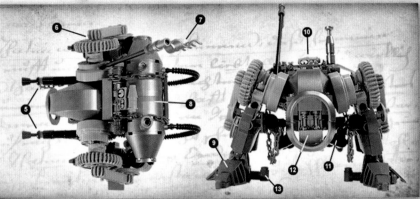

1.	Armoured brass body	6.	Leg actuators	11.	Automatic cannon loader
2.	Smokestack	7.	Banners	12.	Navigational "eye"
3.	Fuel connectors	8.	Steam engine (coal)	13.	Motion stabilizers
4.	Combustion chambers	9.	Foot assembly		
5.	12-pound cannons	10.	Status panel		

DARDENBAHST BY JAMIE SPENCER

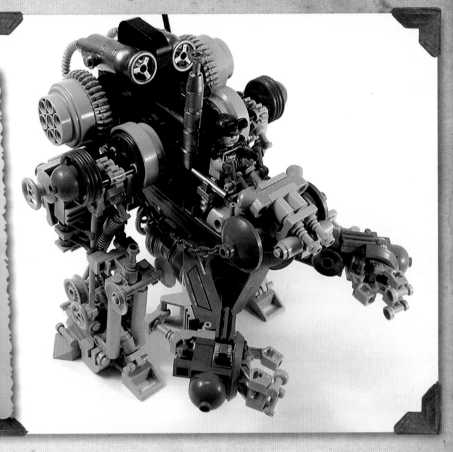

The Dardenbahst is designed to be driven by a single skilled pilot, assisted by several crew members. Among other jobs, it ferries cumbersome repair materials to outlying villages, scrubs down the grungy undersides of massive metal airships, and assists on construction projects under dangerous conditions.

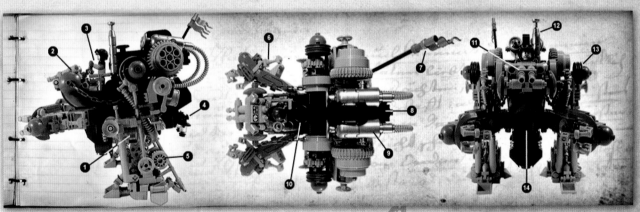

1. Brass water boiler	6. Mechanical arms	11. Dual-machine pistol
2. Instrumentation	7. Banners	12. Smokestack
3. Pilot cab & socket	8. Steam engine (coal)	13. Leg actuators
4. Work lanterns	9. Combustion chambers	14. Maintenance hatch
5. Foot assembly	10. Main steam stop valve	

TRIPODI
BY TYLER CLITES

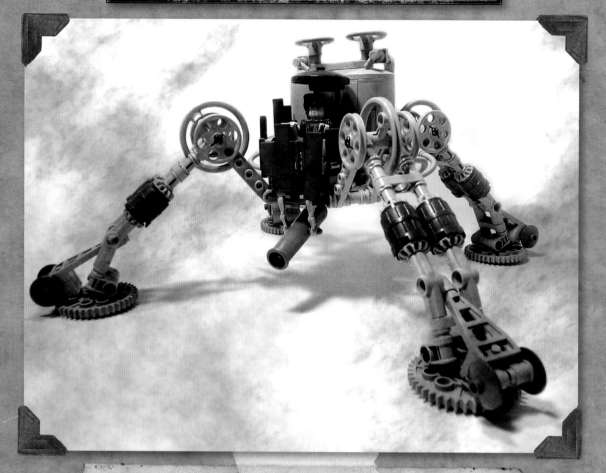

As the debate between two-legged and four-legged amblers continues in the learned halls of our universities, one impatient builder has found an honourable compromise by choosing three legs for this fleet walker. I highly recommend it for daring souls with a need for tripod-fueled adventure.

STEAM PRANCER
BY SIMON JACKSON

Another advocate of three-legged locomotion, Captain Tzidik developed the Steam Prancer. After being cheated in a game of paille maille, he was heard to exclaim, "You are a fraud, a degenerate, and a rogue, sir!" as he thundered down upon the offending party's home in the Prancer. The Prancer has the strength of 12 ordinary draft animals, a fact that Tzidik's nemesis learned firsthand as the enraged Captain sheared the supports beneath the rooflines of the miscreant's summer teahouse!

The TerreQuad's instruments of motion
create a delightful manifestation of fleetness.
At first its spindly legs may appear unstable,
but this amazing contraption can parade
forth as a mobile headquarters, allowing
commanders both creature comforts and a
complete aerial view of the battlefield.

CALLOUSED BOXER
BY ZACH CLAPSADLE

This vessel is often referred to as a "flying boat" because it quite literally floats on the air, achieving altitude with Cavorite propellers. Travelling long distances to deliver cargo, the Calloused Boxer uses tow cables to haul its shipments.

The Boxer is easily recognizable by the distinctive grille shapes over its cowl vents and tail cone. Aerodynamic bulges on the chassis cover the valves and exhaust system.

Developed in the suburban wards of southeast London, the Blue Orpington walker was inspired by the stride of the area's world-renowned chickens. Since the opening of the railway station, the once-peaceful village of Orpington has become a major commercial centre. The walkers help maintain order and supervise cargo exchanges.

The Victoria Steam Carriage

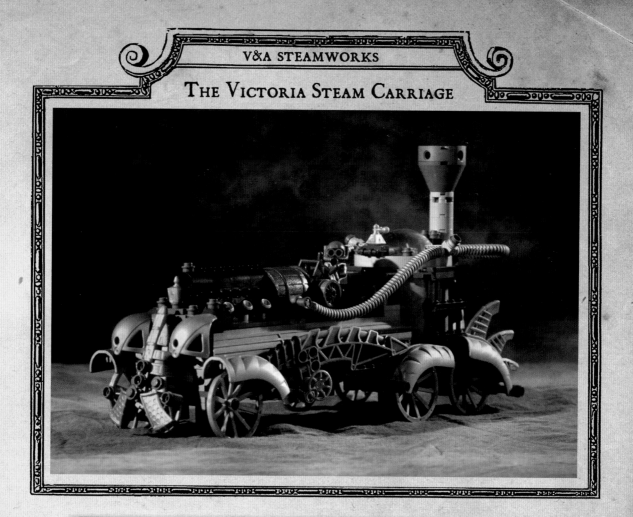

The Victoria Steam Carriage put V&A Steamworks on the map. It was the first coach to harness mysterious artifacts, initially unearthed from a Dover cliffside, that contained strange organic-mechanical metals with unknown powers. The quest for more of these valuable elements has left the surrounding landscape pockmarked with holes and digging-site debris.

POSTAGE
ONE PENNY

PUNKFISH
BY MICAH BERKOFF

Part of a joint venture between Arkov Armoury and the Kensington Fisheries Guild, the Punkfish has the ability to tread directly from the turf into the surf. This coach is used to research the local whitefish population of Cod, Haddock, and Coley, thereby guaranteeing a steady supply of fish and chips to accompany our mushy peas.

Sir, I recommend Mr. Lee's fine establishment in Mossley for the best fish dinner!

Lt. Penfold

THE MOLE
BY JORDAN SCHWARTZ

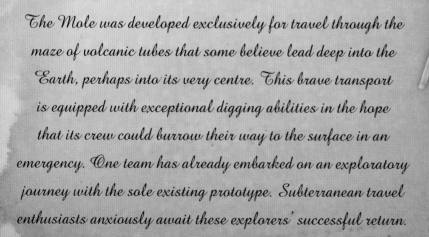

The Mole was developed exclusively for travel through the maze of volcanic tubes that some believe lead deep into the Earth, perhaps into its very centre. This brave transport is equipped with exceptional digging abilities in the hope that its crew could burrow their way to the surface in an emergency. One team has already embarked on an exploratory journey with the sole existing prototype. Subterranean travel enthusiasts anxiously await these explorers' successful return.

This dashing conveyance helped popularize the term "walker bot." The HEX Walker is well suited to performing rescue missions and is featured in many stirring tales of derring-do.

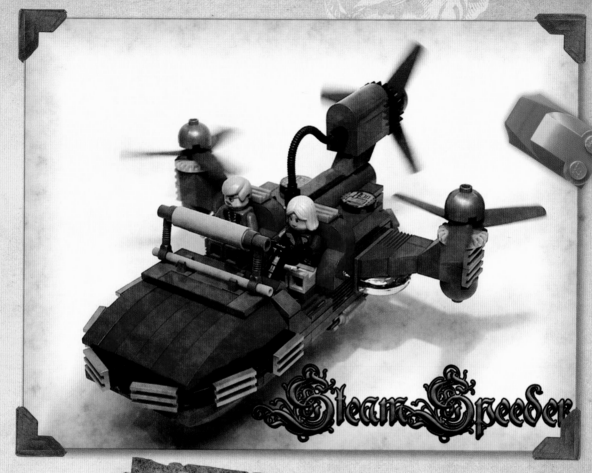

The Speeder was inspired by the work of pioneering genius John Stears. One major design challenge the construction crew faced was that of making it hover. The Cavorite coating the builders used on the underside of the Speeder allows it to achieve remarkably smooth progress as it floats easily over rough cobblestones.

THE BONESHAKER
BY NATHAN PROUDLOVE

Unlike the beloved velocipede of the same name, this armoured transport earned its moniker from soldiers who felt the rattle and boom of its guns deep in their bones. The thunderous voice of the cannon's retort makes the Boneshaker a truly formidable beast.

KAPTAIN KAZOODLE AND THE TRAVELLING CIRCUS OF DOOM
BY NATHAN PROUDLOVE

A recent evening at the circus inspired Proudlove, inventor extraordinaire, to create this travelling stage for sideshow entertainers. After building the inner structure, Proudlove invited the local acting troop to "test drive" it in the neighbouring hamlet, much to the delight of the villagers. Determined to promote circus lore throughout the world, this travelling enterprise tours the countryside and displays the finest sideshow attractions at no cost to the audience!

The Über Zerstörer
by Captain Smog Manufactory

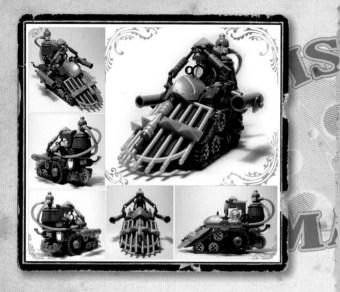

Some officers and military planners have derided the Über Zerstörer (or Super Destroyer) as a wasteful expense. Nevertheless, due to the effectiveness of this machine as a weapon of terror, Zerstörer production was prioritized over previous battle-carriage designs. The unrelenting progress of these cannon-heavy rolling monstrosities has proven that some battles can be won merely by the rattling of sabers. Good show, Captain Smog!

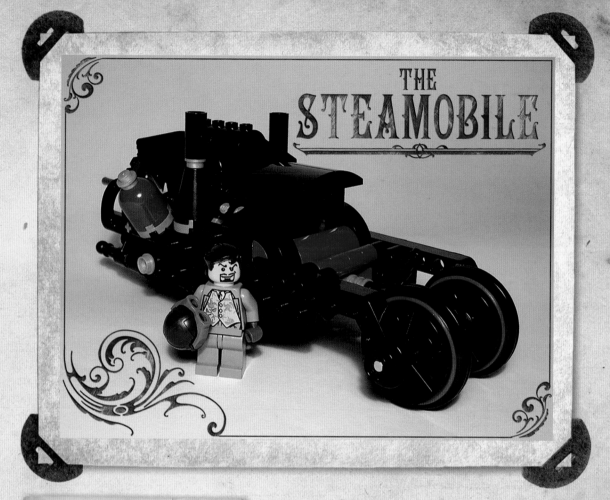

The heavy encumbrance of an oversized boiler has proven to be the greatest engineering challenge to the Steamobile. A constant, close supply of fresh buckets of water is encouraged for the effective operation (and safety) of this massive carriage.

Recently, the Manufactory added a clever steam condenser system which helps minimize the need for vehicle (and driver) hydration, but at the cost of an additional 20 stone of overall vehicle weight. After gentle and patient prodding, the massive Steamobile can achieve heretofore unheard-of levels of acceleration and torque!

2. June

Your Majesty,

The proud tradition of the infantryman (though he may be vulgarly referred to as "cannon fodder") may soon be overtaken by Automatons. We may be seeing a bright day for the Mechanical Man and a dark one for the Common Man.

Filling the hazardous fields of battle, these Mechanical Marvels range from small, man-sized machines to deadly "Iron Men" the size of buildings. Many of these Automatons are so lifelike that they could don tailcoats and play host at a proper gala!

Our crafty inventors and scientists are busily innovating steely threats for those foolish enough to doubt Britannia's military power and exuberance. I have observed that the red eyes of these automated soldiers glow with the glory of service.

Your loyal Servant,

Sir Herbert

ROBOTS AND AUTOMATONS

POST CARD
THIS SPACE FOR ADDRESS ONLY

PLACE
STAMP
HERE

"'More Human than Human'
is our motto..."
—Dr. Eldon Tyrell

TROLL CRUSHER
BY AARON ANDREWS

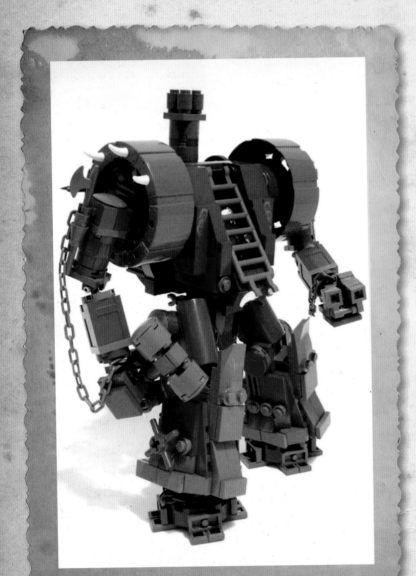

This massive yet elegant ironclad "Soul Crusher" comes from the distant colony of Australia. It delights the ears with a symphony of lovely whirring and clanking sounds as it fulfils its inexplicable mission of crushing souls and other objects in service to its master.

Sir, not the "Soul Crusher" but the "Troll Crusher."

Lt. Penfold

I have been assured by the designer of this fine Automaton that it will NEVER attempt to evolve and destroy the British Empire. Though I must admit the unnerving to-and-fro motion of the single, glowing red eye did not help set my fears to rest...

THE RED-EYED CENTURION
BY ANDERTOONS

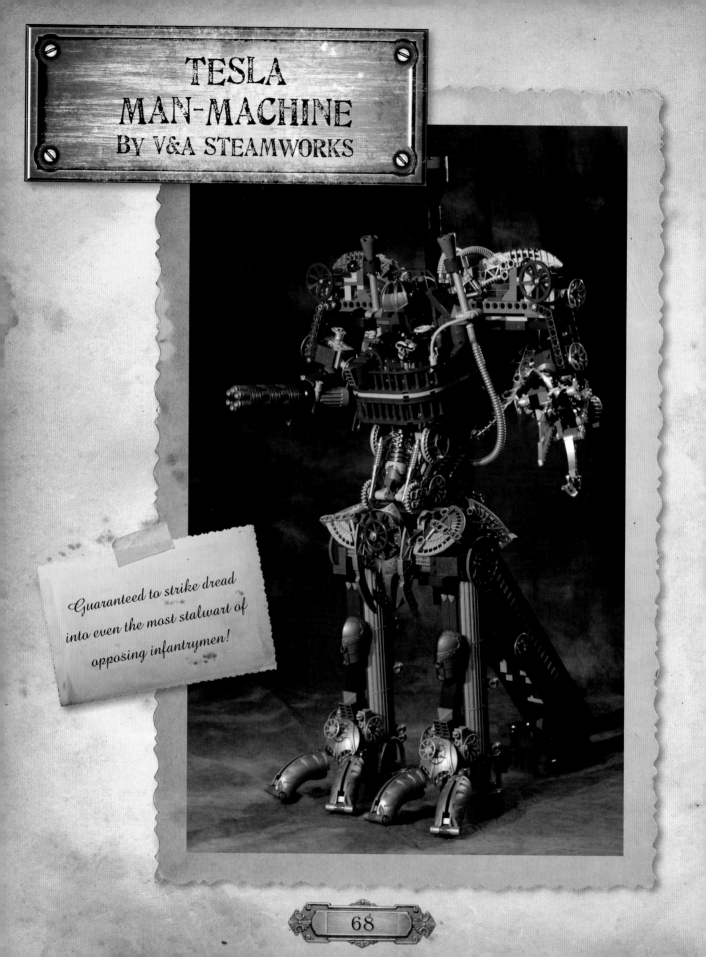

TESLA MAN-MACHINE
BY V&A STEAMWORKS

Guaranteed to strike dread into even the most stalwart of opposing infantrymen!

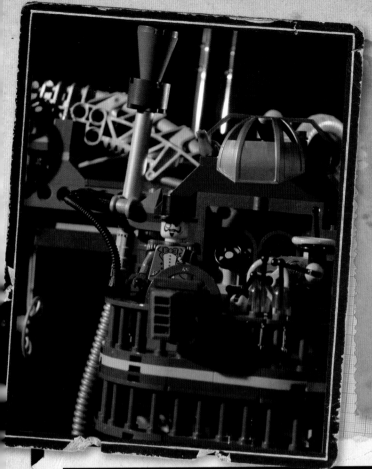

Developed with the help of our cleverest of cohorts, Nicola Tesla, the Man-Machine towers over the battlefield. This gargantuan robot is capable of wreaking havoc on a level previously undreamt of!

Protected by thick armour, this metal soldier incorporates a Herculean Gatling Gun mounted on one arm and, on the opposing arm, a great, pinching mechanical hand and a flamethrower. An observation deck provides an excellent vantage point for Generals.

N. TESLA APPROVED

ROBOT RESEARCH LABS
BY V&A STEAMWORKS

I entered the familiar parlour of V&A Steamworks and was warmly greeted by Lord Himbers's dogsbody. We took a winding path through the richly appointed library and into the vast workshop space. Networks of wires and hoses snaked past piles of various diagrams and complicated-looking components.

The assembled scientists regaled me with tales of chivalry and derring-do. When I inquired as to the completion status of their latest invention and a possible demonstration, I was quickly distracted with offers of baked treats with clotted cream and tropical fruit jams. In the end, I never saw the promised mechanical wonder function.

(This quibble aside, the scones were delicious!)

He may not be suited for houses with pets or rat-sized children...

Lt. Penfold

What better way to impress your guests than with a perfect gentleman who happens to be a Metal Man? Recent technological breakthroughs from the inventor's workshop now allow you to hobnob with your very own personal (and blindly loyal) mechanical manservant!

He will tirelessly swap your chamber pots, kill stray rats, and prepare the finest of teas in your best china. This anthropomorphic brute has the manners of a dandy and the strength of a hundred men. I've placed an order for three.

QUEEN'S HAMMER
BY HAMMERSTEIN NWC

Piloted by a handsome Yorkshireman, Commander Hampton Grimes, this mighty machine is armed with a Coal Fusion Cannon. Affectionately nicknamed "The Hammer," this steam-powered addition to the field of conflict often spells the difference between victory and defeat for our combat regiments.

M-6 PROTECTOTRON
BY TYLER CLITES

My initial researches into the origins of these fine Mechanical Men-at-Arms led me on a merry chase. First attributed to the mysteriously named "Master Donut," these marvels eventually turned out to be works of that familiar scamp Professor Clites.

When confronted with his misleading mendacities, the professor explained that a rival professor had been engaging in a long and drawn-out campaign of dire espionage in hopes of stealing Professor Clites's secrets—hence the nom de guerre. According to rumour, a cup of "tainted" Earl Grey tea has resolved the conflict in a permanent fashion.

PROUD LARRY
BY TYLER CLITES

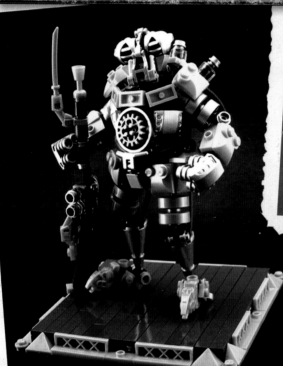

At first I was put off by Proud Larry. At rest, he produced a sound akin to a horde of sinister insects. Yet I found myself exclaiming "By George!" when he stepped forward and offered up a mighty metal hand in greeting. Styled with a tip of the top hat to medieval armour, the golden flanks of our metal friend Larry shine brilliantly as he sallies forth, firing round after round from his charming rifle.

Proud Larry can battle up to one half-hour with just a single winding!

Lt. Penfold

OTTO THE OTTOMAN AUTOMATON
BY ROD GILLIES

The Iron Duke
by Rod Gillies

This hardy Automaton hails from the peat-filled Highlands. From what I could discern from the thickly accented speech of the inventor, "Something, something...freedom... something...sheep...something..." I leave it to Penfold to attempt a further translation of the Viscount's challenging words.

Yet, a quick assessment reveals the exceptional principle of construction underlying this daunting beastie, "The Iron Duke." Sheathed in meticulously crafted brass armour, the Duke can easily rout whole squads of opponents. You shall be the victor in your Vendetta du Jour with the Duke by your side.

IRON BRAWLER
BY TIM ZARKI

Though a purely cold and calculating machine often executes the noble purposes of the Empire best, at times a hybrid of man, machine, and monster offers superior service. After all, when diplomacy has failed, the next best solution is a generous dose of crushing, giant claws. I guarantee smooth negotiations when you show up clad in the Iron Brawler.

The impressive claws are even precise enough to gather haddock for fish and chips!

Lt. Penfold

OCULUS DIVE SUIT
BY TIM ZARKI

Conquest of the deep requires foresight, organization, and a bloody giant harpoon gun. The Oculus provides the gun; you provide the will to master undersea denizens as you engage in fisticuffs with giant squids and wayward whales! Withstand killing pressures as you conquer the dark abyss.

Shrapnell Automaton
by Captain Smog Manufactory

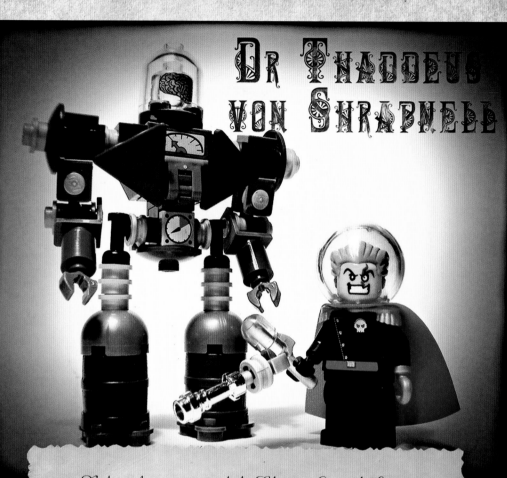

Dr Thaddeus von Shrapnell

Before the invention of the Electro-Optical Logic Machine (which uses photoconductors and gas-discharge tubes to formulate logic and courtesy calculations), the designers at Captain Smog Manufactory were challenged to find a "brain" to command their robotic creations. Dr. Thaddeus von Shrapnell came upon the cost-saving measure of using real human brains! This technology allowed the doctor's machines to govern their own behaviour with willful independence of thought and motivation.

BOILER KNIGHT
BY MICAH BERKOFF

A miscommunication with the sword smiths at the Royal Weapons Forge spawned the mighty Boiler Knight Division from Arkov Armoury. It all began when a misread order for (20) 3-foot-long swords was delivered to the Armoury.

Imagine Admiral Arkov's surprise when he received (3) 20-foot-long swords! Not one to waste finely crafted weapons, the Admiral commissioned the construction of these formidable suits of exo-gallantry to wield the potent golden scimitars.

Technically they are broadsords, sir.
 Lt. Penfold

9. July

Sterling Blunderbusswerks—Target practice!

Most Gracious Queen,

Allow me to welcome Your Majesty to the competitive world of arms sales. The offerings represented in the catalogues and advertisements I have collected in my research pursuits are available for immediate purchase by our armed forces! My ears are still ringing from the numerous demonstrations I have beheld.

Sundry other items of remarkable utility are included herein, which may have applications outside the realm of Defence. For instance, I have finally found a much-needed reputable source for quality pith helmets!

By Your Majesty's command,

Sir Herbert

ARMAMENTS
AND
SUNDRIES

THIS SPACE FOR WRITING MESSAGES

POST CARD

THIS SPACE FOR ADDRESS ONLY

PLACE
STAMP
HERE

*"Not very sporting to fire on
an unarmed opponent…"
—Roy Batty*

ELECTROIONIC DISCOMBOBULATOR
BY TOMMY WILLIAMSON

The devastating Discombobulator is a collision of beauty and menace. Phantasmal forces are produced by the interaction of magnetic gases within the Discombobulator's intricate and shiny components. Gorgeous technology at its most gorgeous!

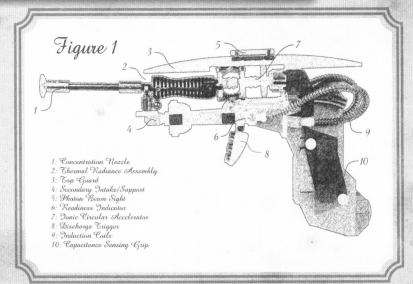

Figure 1

1: Concentration Nozzle
2: Thermal Radiance Assembly
3: Top Guard
4: Secondary Intake/Support
5: Photon Beam Sight
6: Readiness Indicator
7: Ionic Circular Accelerator
8: Discharge Trigger
9: Induction Coils
10: Capacitance Sensing Grip

Electroionic Discombobulator

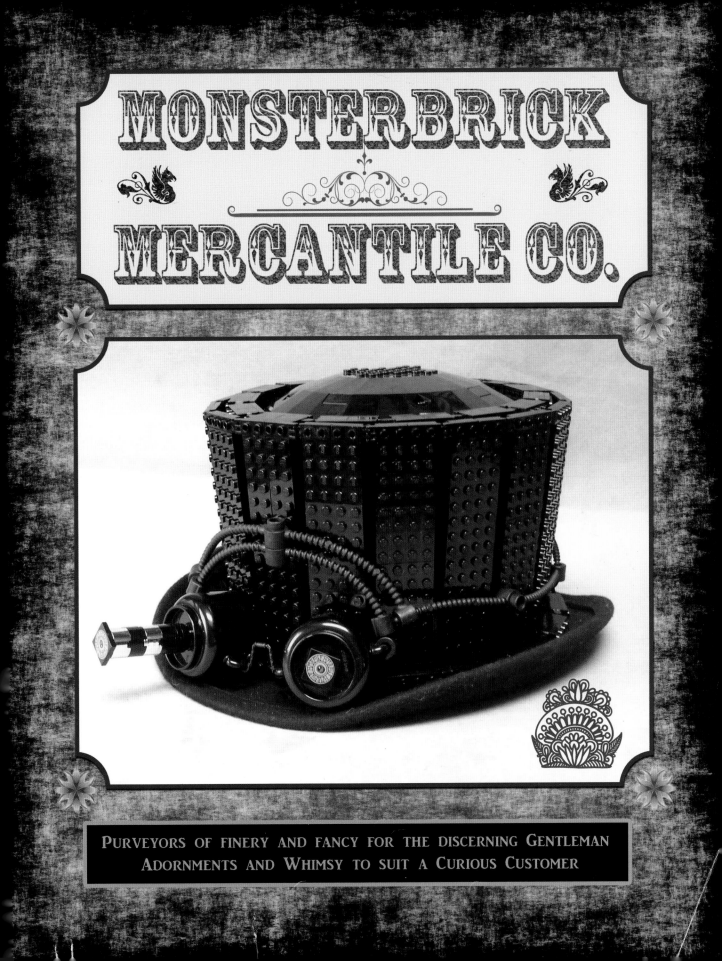

MONSTERBRICK

The handsome MB No. 5 is a richly textured chest featuring a boxlike shape for enhanced durability! Lined with the finest Platypus and Emu furs, it will keep safe your precious things.

Crafted from polished Ebony, the MB No. 12 promises to turn your most trifling ideas into the finest prose.

Weary of burning books to fuel your smoke signals? The MB No. 8 is your answer! Message your comrades via the power of radiotelegraphy and its complicated code-speak!

MERCANTILE CO.

The MB No. 9 features a mysterious magneto generator crank. The rotary dial makes a reassuring clicking sound.

The MB No. 3's Cylinders of Beeswax allow the capture of your very breath! Preserve the kind preachings of your elders in a permanent fashion!

Bits and Bobbins! What better way to mend your adventure-worn finery than with the miracle of thread! Create ship sails or jodhpurs with ease!

Hello?

Who is there?

A bright and fantastic future, that's who! The MB No. 7 has a sleek, modern style; the faceted dial adds a touch of luxury.

Does a camera truly steal one's soul? Mystify the gullible with the arcane and incomprehensible power of the MB No. 22!

MONSTERBRICK'S DERRINGER
BY MONSTERBRICK MERCANTILE

Nicknamed "The Problem-Solver Revolver," the tiny MB No. 1 Derringer is ideal for covert agents or anyone for whom discretion is of the utmost importance!

BRAVEHEART DISRUPTOR
BY V&A STEAMWORKS

SPREADING IMPERIALISM
AND PEACE SINCE 1865

V&A STEAMWORKS

GEAR MAKES THE MAN!

Phase Haggis Pistol

Queen's Fist
Rocket Pack

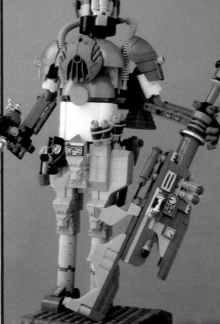

"Old Misty"
Breathing Aid

GX200
Entrenchment
Tool

Utility Cylinders

Auto Scribe
Mapping Device

Leather Gadget Bag

Sticky Dolphin
Magnet Mine

Braveheart Disruptor

JOIN THE SPECIAL BRITISH
COLONIAL FORCES TODAY!

TESLA'S PIGEON PISTOL
BY V&A STEAMWORKS

Having coined the term "Lightning Gun," Mr. Tesla put his full powers into the crafting of the insanely powerful— yet elegant—Ray Pistol known as "The Pigeon." Guaranteed to create disbelief and awe in the hearts of your rivals!

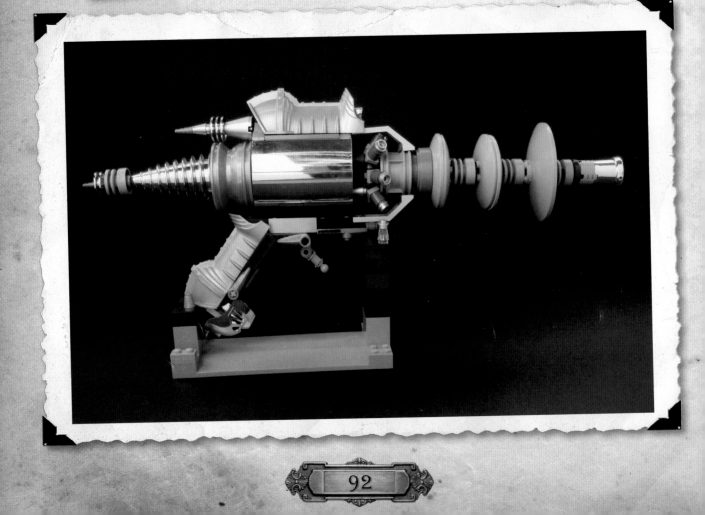

ORRERY BY V&A STEAMWORKS

Know the secrets of the Universe!

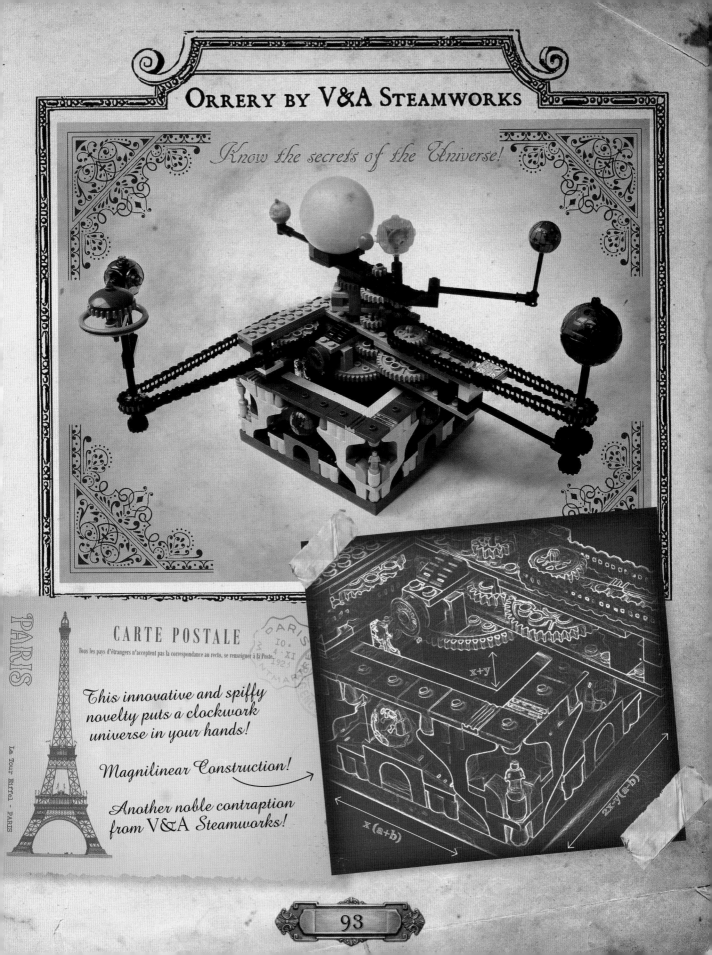

This innovative and spiffy novelty puts a clockwork universe in your hands!

Magnilinear Construction!

Another noble contraption from V&A Steamworks!

$x+y$

x

$x(a+b)$

$2x-y(a+b)$

CROWN ROYALE INFINITY RIFLE
BY V&A STEAMWORKS

Why lurk in the shadows when hunting big game? Issue forth the sweet taste of adventure with the all-new Crown Royale Infinity Rifle from the crack shots at V&A Steamworks. Don't let the elaborate etchings fool you. This weapon will deliver a powerful, pulsed-wave modulation beam capable of turning 12-inch plate steel into treacle pudding!

FOR QUEEN AND COUNTRY!

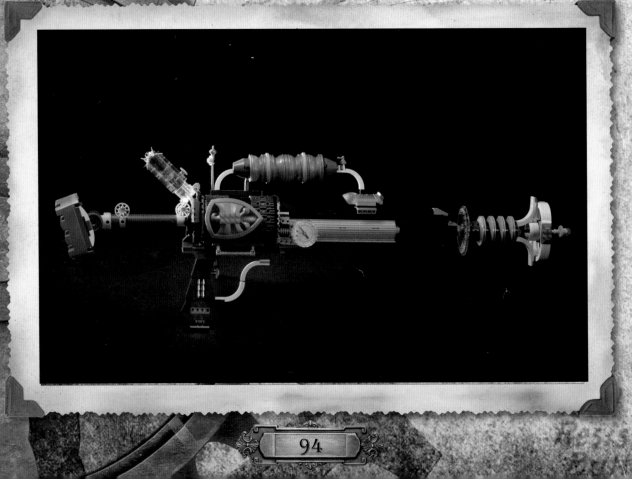

THE ANNIHILATOR
BY CAPTAIN SMOG

Her Majesty's elite soldiers prefer

THE
ANNIHILATOR

Built to blast enemies into very small parts

The Annihilator causes cruel and permanent disassembly by means of experimental vapours channelled through a sonic stabilizer.

My Queen, I am not entirely sure what this jargon means, but I have been assured it is fairly reliable and often safe...

Lord Sterling's Rifle by Sterling Blunderbusswerks

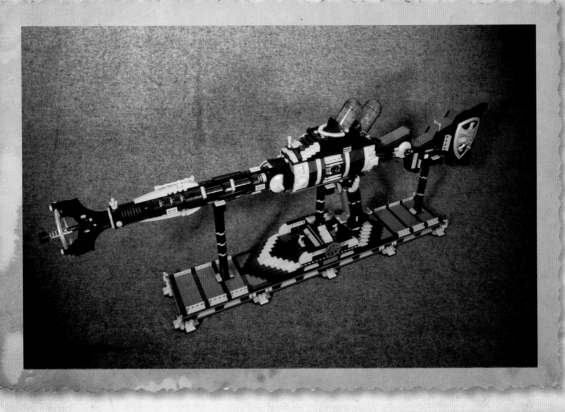

Famed for their vast inventory of "vengeance weapons," the engineers at Sterling Blunderbusswerks have forged a complex relationship between death beams and richly textured burnished hardwood. An abundance of metallic embellishments and elaborate gold detailing means Lord Sterling quality!

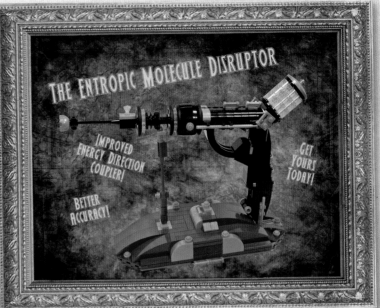

LORD STERLING'S ENTROPIC MOLECULE DISRUPTOR BY STERLING BLUNDERBUSSWERKS

MISS DONOVAN'S FARNSWORTH

BY STERLING BLUNDERBUSSWERKS

Want to sense the evil intentions of
your enemies? Care to view the full
spectrum of your rivals' communications?
The Farnsworth is for you!
Guaranteed to be highly complicated!

SCIENTIFIC SCALE
By Blake Baer

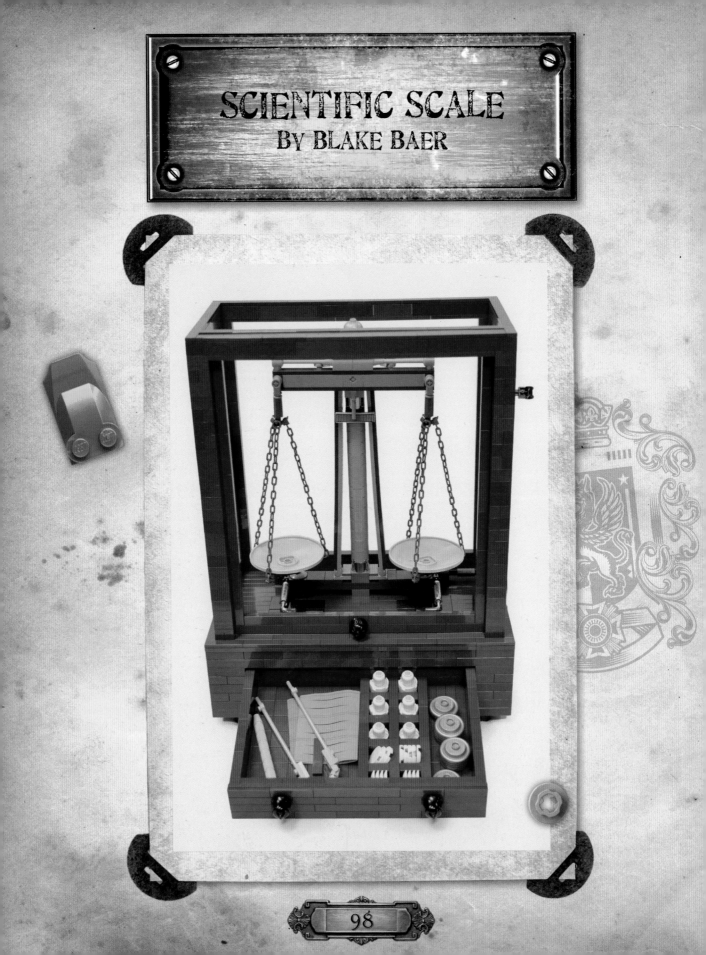

MODEL 1858 REMINGTON .45
BY MICAH BERKOFF

Often, one must forgo the fickle nature of otherworldly gadgets and Ray Guns for the practicality of a strapping good sidearm. Let the dependable Model 1858 aid you in delivering swift justice to scurvy ne'er-do-wells!

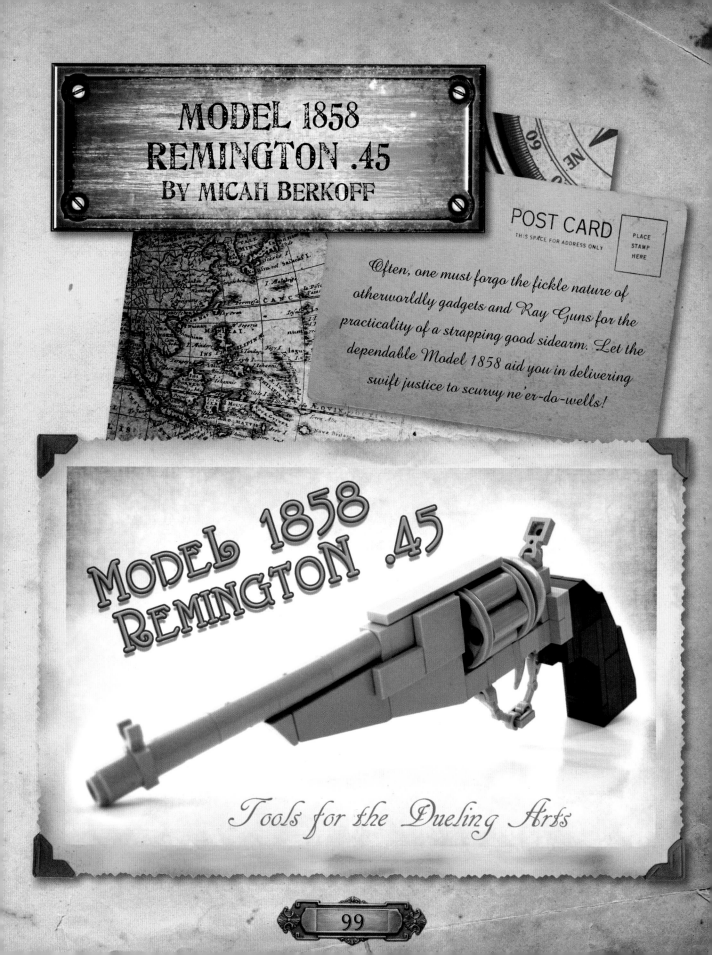

MODEL 1858 REMINGTON .45

Tools for the Dueling Arts

Your Majesty,

Often my heroic adventures take me to faraway locations,
where I have heard a great number of strange and marvelous
tales. None was more intriguing to me than the rumour of a
mysterious object called the "Ark That Walks."

I journeyed to countless ancient temples and sought out
various religious sects in pursuit of this legendary Ark.
Finally, through some generous palm greasing, I found
myself on a noisy train bound for Kathmandu. Once I
arrived safely in that remote city, I sought out a native
guide, a man who called himself Blaylock and had been
recommended by mutual friends in Bombay. He was
a disreputable character with a scarred face and a stony
demeanour, but a few English pounds loosened his tongue,
and eventually he led me to a vast underground cavern that
had long been kept secret by the inhabitants of his poor
village. The locals had no idea of the true nature of the
feared object hidden within…

CABINET OF CURIOSITIES

Albinus Curio Cabinet
V&A Steamworks

Wunderkammer
V&A Steamworks

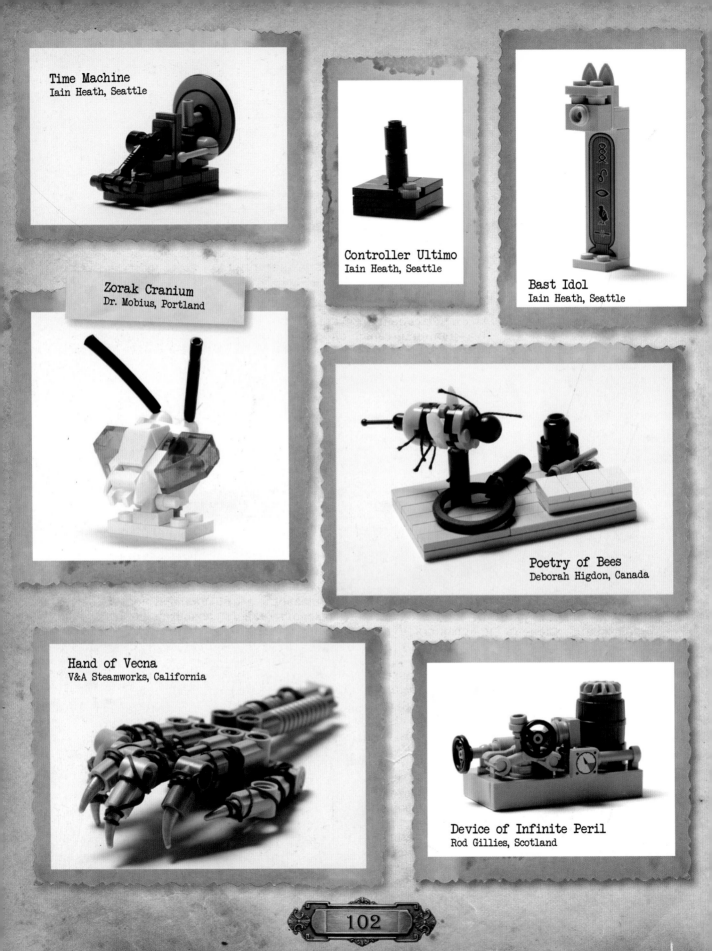

Time Machine
Iain Heath, Seattle

Controller Ultimo
Iain Heath, Seattle

Bast Idol
Iain Heath, Seattle

Zorak Cranium
Dr. Mobius, Portland

Poetry of Bees
Deborah Higdon, Canada

Hand of Vecna
V&A Steamworks, California

Device of Infinite Peril
Rod Gillies, Scotland

Bilund Cylinder
Joe Meno, North Carolina

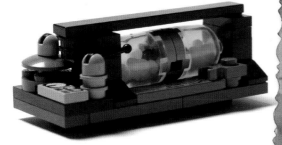

Anomalocaris
Shannon Ocean, Down Under

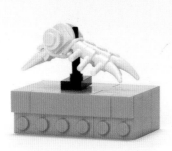

Wayne Wagen
Wayne Hussey, Seattle

... Upon investigation of the ancient cave system, I found, at long last, the Ark That Walks. It was an odd device in the form of a sizeable Queen Anne–period hardwood cabinet, now a home for crickets and cobwebs. Protruding from the repository were mechanical arms and legs, currently in a state of disrepair, that appeared to have granted the cabinet the ability to somehow move about great distances and collect objects and curios. Nearby, a weathered leather picture album bore a single handwritten word: "Wunderkammer." The Ark contained a wonderful collection of photographs depicting a great many items both mysterious and fabulous, but no description or mention of how the strange cabinet had functioned or what arcane magicks had powered it and its thirst for artifacts.

I cannot say whether the device was capable of capturing photographs itself, nor whether its unknown inventor had created the devices in the collected images...

Ark of Bast
Plums Deify, Seattle

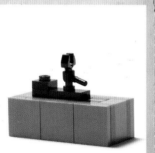

Mini Black Fantasy
Nannan Zhang, Dallas

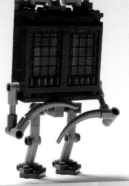

Mini Wunderkammer
V&A Steamworks, California

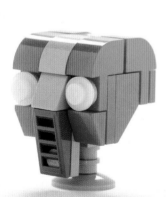

Idol of Anubis
Iain Heath, Seattle

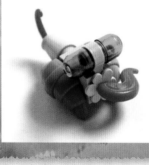

Splorp
Prof. Ley Ward, Canada

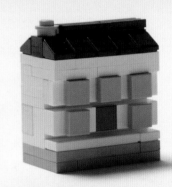

House of Heather
Prof. Heather, Seattle

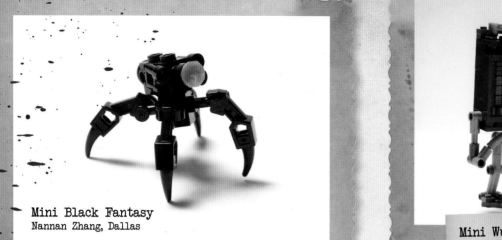

HumanoidBOT
rongYIREN, China

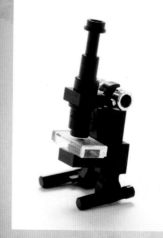

Monsanto Might Microscope
Carl T. Merriam, California

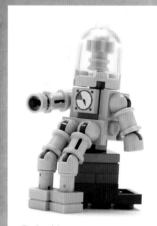

Roboticus
Théo Bonner, Massachusetts

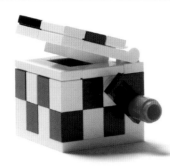

Check Your Box
Alex Eylar, Earth

Steam-Powered Lamp
Pascal Schmidt, Germany

Micro Hogwarts
Countess Sterling, Trempealeau

BlackPod
Nannan Zhang, Dallas

The Pee-vil
Milán Bikics, Hungary

Fiji Mermaid
Nathan Proudlove, Canada

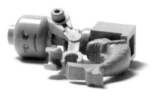

Laughing at Gravity
Katie Walker, Washington

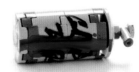

Tagger
Cole Blaq, Graffitiville

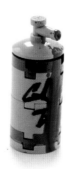

... The empty shelves evidenced that the original artifacts had been pillaged long ago. Although I couldn't negotiate the acquisition of the cabinet, as the village elders feared some ancient curse would be visited upon their home if the Ark were removed, I was able to barter the purchase of the photographs themselves!

May I suggest we revisit this quaint hamlet, enlighten its inhabitants as to the ways of proper civilization, and then retrieve the "Wunderkammer" for proper safekeeping back in Great Britain.

Yours in Adventure!

Sir Herbert

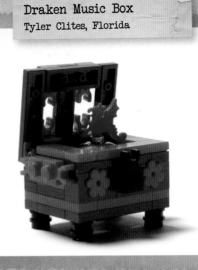

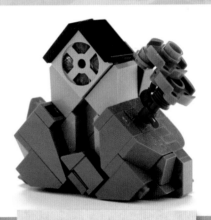

Island of Micro
C.J. Edwards, Pennsylvania

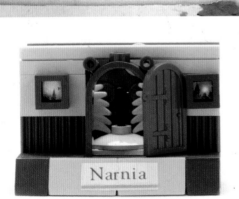

Wardrobe
Sean and Steph Mayo, Maryland

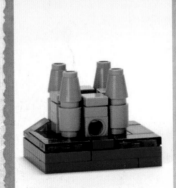

Castle of the Wee Loch
Matthew Maulfair, Unknown

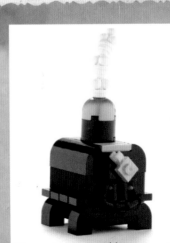

Fire of Innovation
Baron Von Sterling, Trempealeau

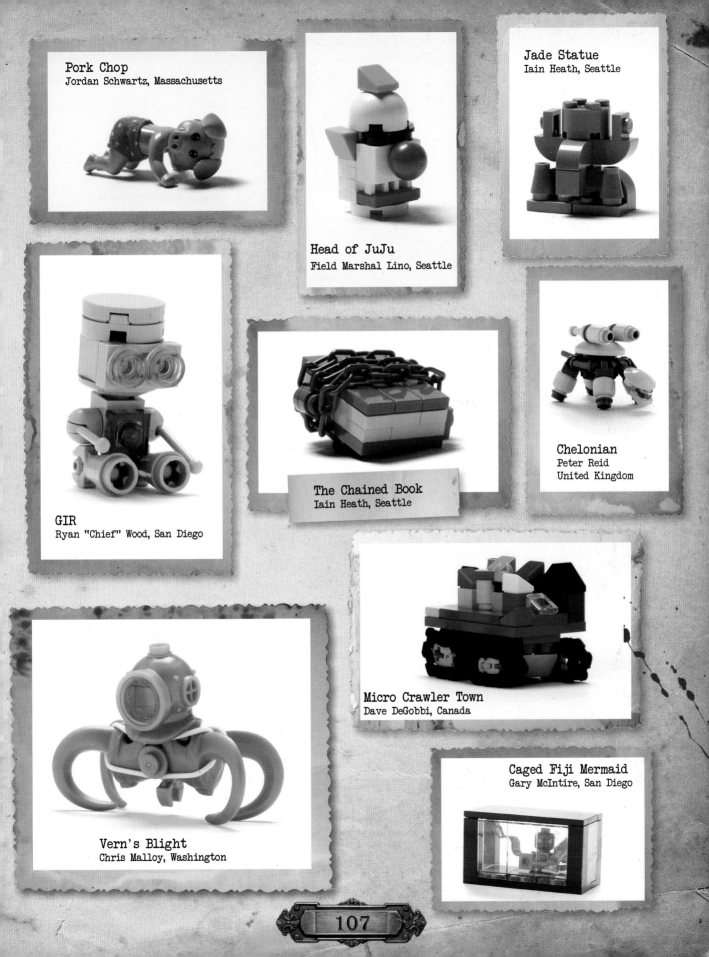

Pork Chop
Jordan Schwartz, Massachusetts

Head of JuJu
Field Marshal Lino, Seattle

Jade Statue
Iain Heath, Seattle

GIR
Ryan "Chief" Wood, San Diego

The Chained Book
Iain Heath, Seattle

Chelonian
Peter Reid
United Kingdom

Micro Crawler Town
Dave DeGobbi, Canada

Vern's Blight
Chris Malloy, Washington

Caged Fiji Mermaid
Gary McIntire, San Diego

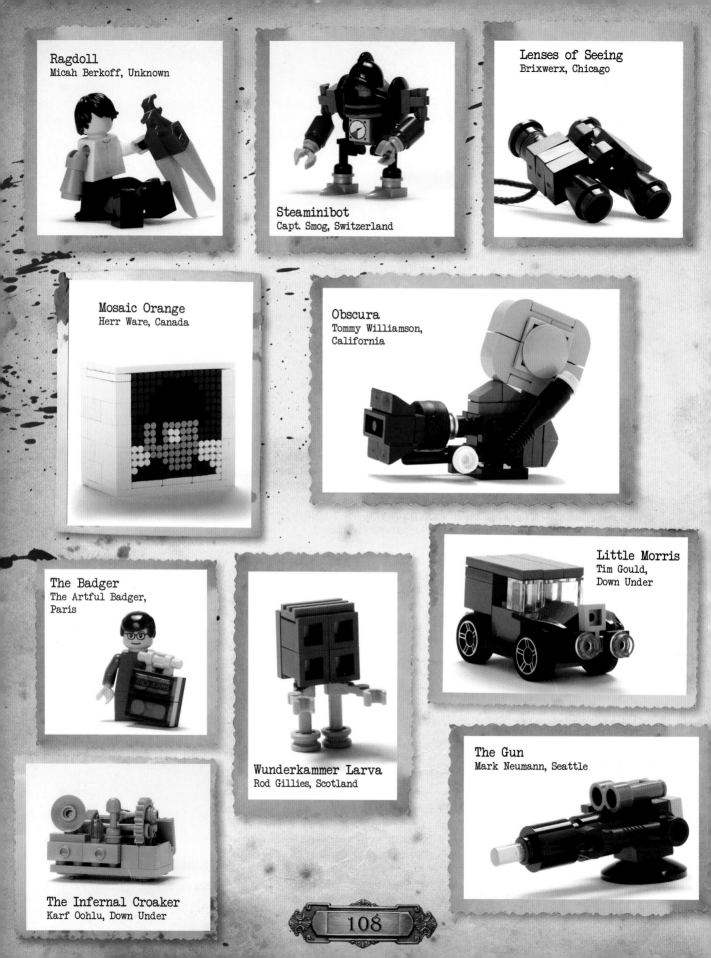

Ragdoll
Micah Berkoff, Unknown

Steaminibot
Capt. Smog, Switzerland

Lenses of Seeing
Brixwerx, Chicago

Mosaic Orange
Herr Ware, Canada

Obscura
Tommy Williamson,
California

The Badger
The Artful Badger,
Paris

Wunderkammer Larva
Rod Gillies, Scotland

Little Morris
Tim Gould,
Down Under

The Gun
Mark Neumann, Seattle

The Infernal Croaker
Karf Oohlu, Down Under

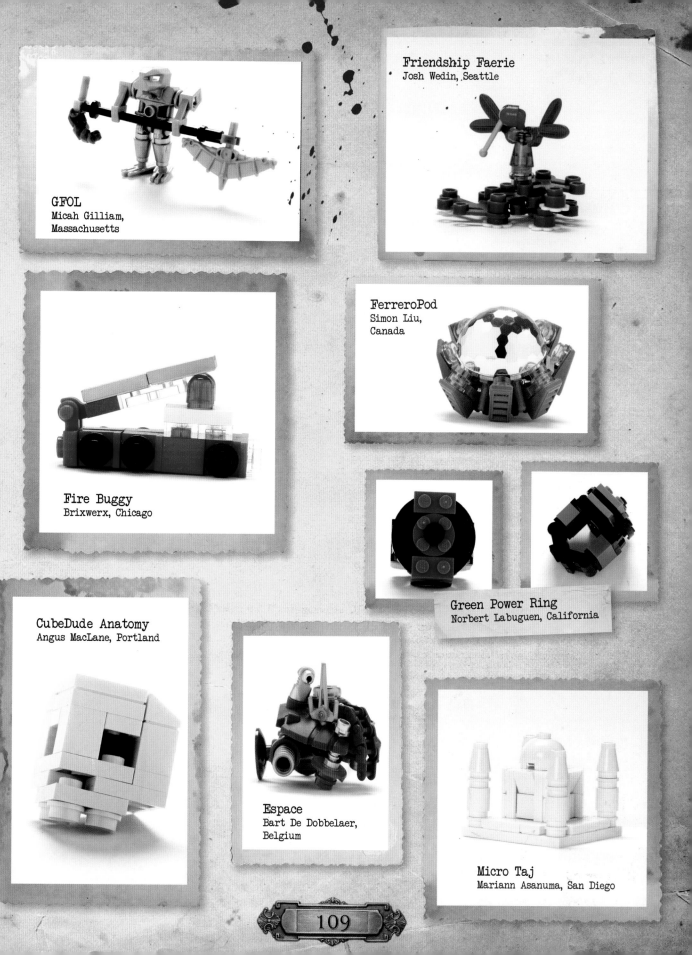

GFOL
Micah Gilliam,
Massachusetts

Friendship Faerie
Josh Wedin, Seattle

FerreroPod
Simon Liu,
Canada

Fire Buggy
Brixwerx, Chicago

Green Power Ring
Norbert Labuguen, California

CubeDude Anatomy
Angus MacLane, Portland

Espace
Bart De Dobbelaer,
Belgium

Micro Taj
Mariann Asanuma, San Diego

27. September

Aboard Her Majesty's Victory—

Location Classified

Your Majesty,

The dark shadow of constant nautical threats
continues to inspire the development of powerful
ships and weapons for the Empire's defence.
A brave Captain in the wheelhouse is required
to pilot these seafaring vessels as they protect our
shipping routes from foes abroad.

The Royal Navy has a long and noble history,
and no wonder—our brave sailors face off
against Krakens and scurvy with equal valor!

Yours in service,

Sir Herbert

SEVEN SEAS

"The royal navy of England has ever been its greatest defence and ornament; it is its ancient and natural strength; the floating bulwark of the island..."

—Sir William Blackstone

VULCAN
BY ROD GILLIES

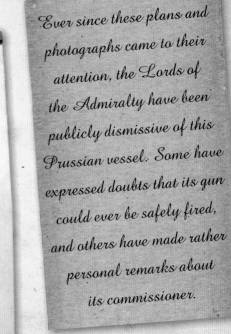

Ever since these plans and photographs came to their attention, the Lords of the Admiralty have been publicly dismissive of this Prussian vessel. Some have expressed doubts that its gun could ever be safely fired, and others have made rather personal remarks about its commissioner.

In private, however, Their Lordships are concerned that Prussia has made a bold leap forward with this incredibly destructive new weapon.

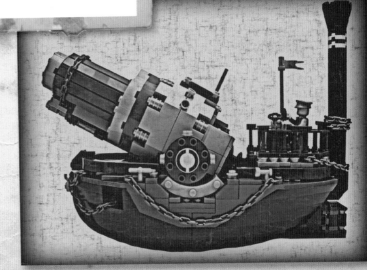

THE NAUTILUS
BY "FORCES UNKNOWN"

Little is known about this elusive vessel, despite its distinctive construction. It is said to have been developed by a mysterious rogue scientist. Rumours tell of a tapestry-laden Baroque interior with Turkish baths, a pipe organ, and a smoking room! The secretive Captain apparently pursues a vendetta against the warring nations of the surface world.

UNDERSEA STEAM EXPLORERS
BY TYLER CLITES

Many of Neptune's treasures remain a mystery, and what little we do know comes from the highly secretive Professor T. Clites. In his pursuit of the legendary sunken Knights Templar treasure ship, Prof. Clites has produced some of the most jaw-dropping photos of the fathomless abyss ever seen. Many thought this mythical galleon impossible to find, much less investigate, yet Prof. Clites laughed at the treacherous undersea pressures found at such depths and created a submarine, the HMS Perception, capable of plunging to the seafloor to visit the wreck.

YEOMAN GUSS DE BLÖD'S

MYSTERY SHIP

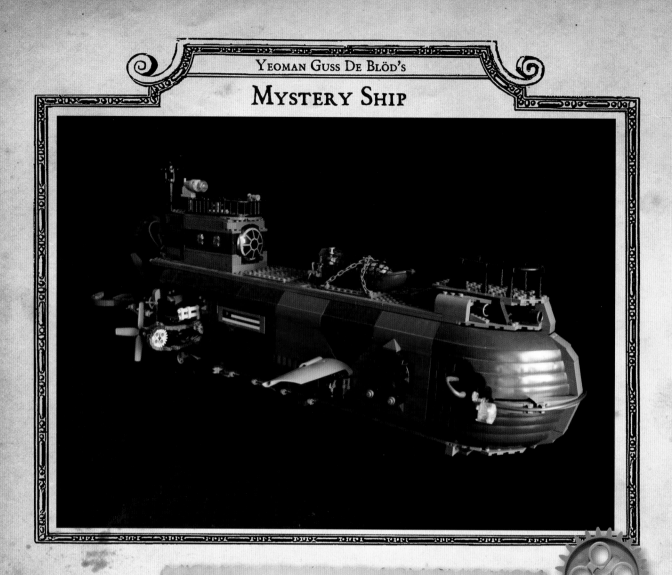

Photographs of this mysterious Underwater
Fishy Object (UFO), taken by Yeoman Guss
De Blöd, were initially thought to depict a
frisky whale or perhaps a gathering of mackerel.
Imagine the surprise when, upon further analysis
of the photographs, this phantom vessel was
revealed! Yeoman De Blöd first noticed the
craft whilst discharging his photographic analysis
duties for the Undersea Steam Explorers.

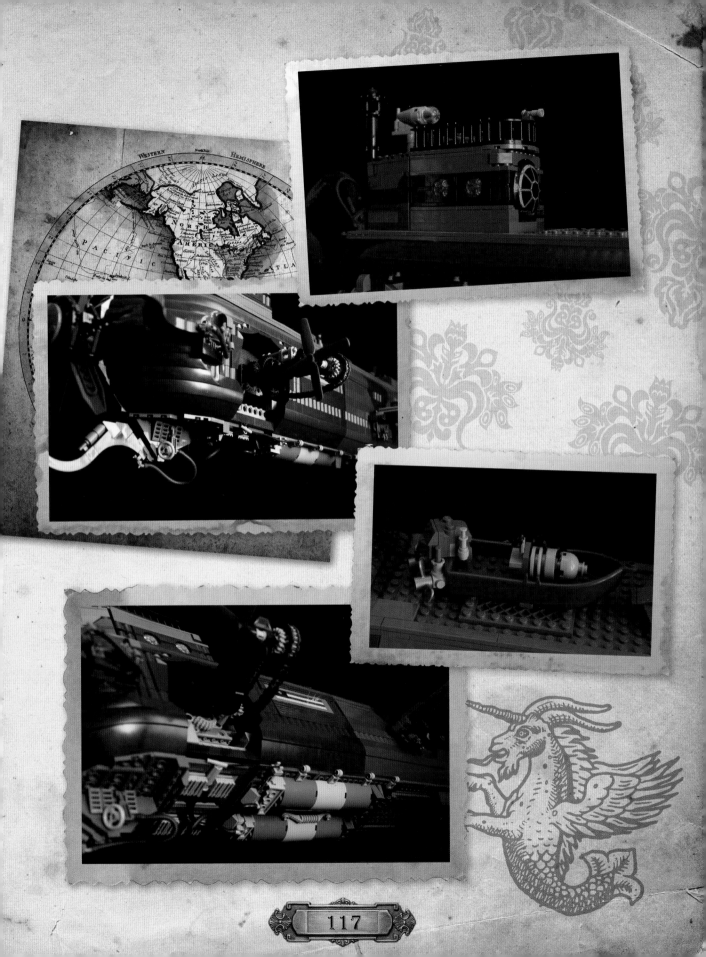

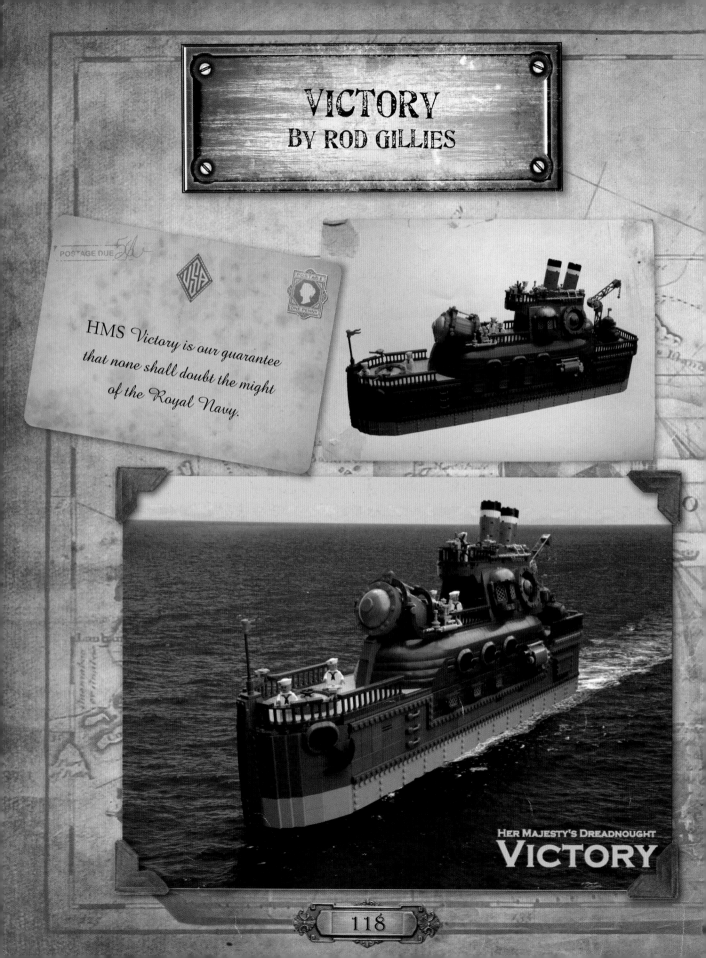

VICTORY
BY ROD GILLIES

HMS *Victory* is our guarantee that none shall doubt the might of the *Royal Navy*.

POSTAGE DUE

POSTAGE ONE PENNY

HER MAJESTY'S DREADNOUGHT
VICTORY

HER MAJESTY'S DREADNOUGHT
VICTORY

HMS *Victory* is the largest and most expensive vessel afloat. Armed with six long-range guns designed to fire the latest nitroglycerine shells, it is capable of inflicting devastating strikes against both naval and shore targets. The *Victory* is also equipped with carbines and anti-aircraft weapons for close-range defence.

This vessel is home to a squad of the famous Navy Seal-Divers. These brave men, equipped with their distinctive diving apparatus made from seal skins, are renowned for their exploits.

FULTON'S REVENGE
BY JORDAN SCHWARTZ

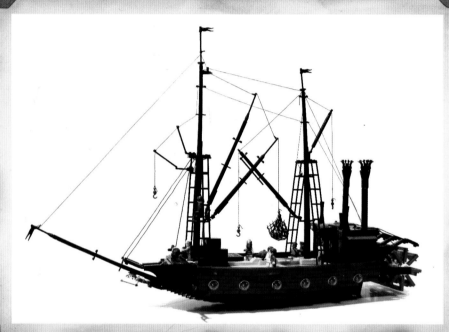

The launch of Fulton's Revenge from the Belfast shipyards brought the vessel alongside the HMS Victory in a well-orchestrated publicity event. Sir Nadroj, the clever shipping magnate, then took to the wheelhouse and guided the newly christened Revenge to the deepwater docks of Southampton, where it was readied for its maiden voyage. Fulton's Revenge, officially the largest paddle-schooner in the world, continues its voyages around the globe, much to the delight of fans both in England and abroad.

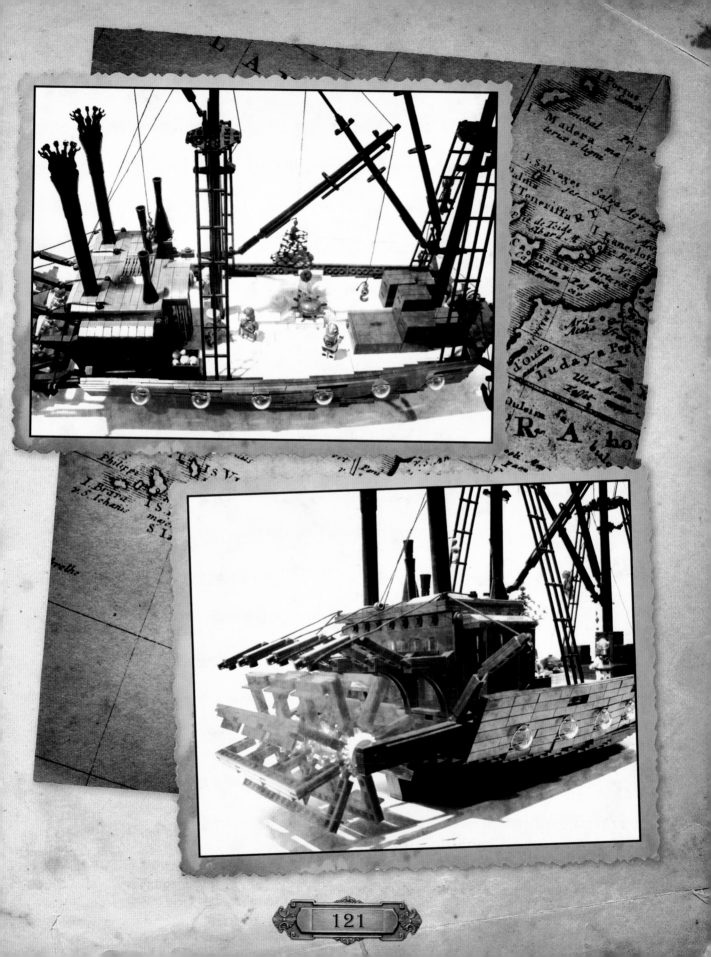

HMS Nautica
by Rod Gillies

LENGTH: 63' 4" BEAM: 15' 9"
DISPLACEMENT: 114 TONNES
SPEED: 14 KNOTS SURFACED, 9 SUBMERGED
MAXIMUM DEPTH: 80' CREW: 4-6
ARMAMENT: 2 TORPEDO EXPULSION TUBES
TORPEDO: 6X 12OZ NITROGLYCERINE WARHEAD

POST B GARD

CORRESPONDENCE ADDRESS ONLY

Despite the rapidly growing numbers of submarine craft in
other navies, the Lords of the Admiralty were initially
sceptical of the promise of these new hybrid vessels.
My Navy sources tell me that launches of experimental
craft like the Nautica were conducted in the utmost secrecy,
as is appropriate for all endeavours of this new branch of the
Royal Navy, now known as the "Silent Service."

DR. SCHWEITZER'S SW – PHYSETER I
BY RUBEN RAS

Dr. Schweitzer's Physeter submersible is motivated by a cutting-edge high-pressure, twin-turbine engine from the US Navy. The engine is a vast improvement over the more common steam-turbine motive power currently deployed by most undersea pilots. How the doctor came upon such technology is still a point of contention amongst his peers.

On the ship's recent eastbound journey from the Port of New York toward Glasgow, it was thought that a faulty high-torque screw rod resulted in the loss of a precious brass propeller. The incident resulted in an unscheduled visit back to the Yanks' dry dock, where various stress fractures were discovered in the ship's understructure. Upon further inspection, it was determined that the damage was most likely caused by the impact of a torpedo attack!

❧ O'Neill's Mini Submarine ❧
by Rod Gillies

Periscope

Access Hatch

Explosive Harpoon

Three-Bladed Screw

Control Planes

Produced by the O'Neill Company of Belfast, the iconic Mini Submarine is perfectly designed for operations in shallow coastal waters. Only the shortage of potential crew members limits the wide deployment of this submersible for duties throughout the Empire. The Admiralty bemoans "the modern sensibilities which forbid the employ of children."

HMS Atlantica
by Rod Gillies

Working closely with the Royal Society,
Commander Taffey Lewis of the Royal Navy has
developed the first submersible to cross the Atlantic
without recourse to surface passage; the Atlantica
has become a potent symbol of our naval supremacy.
The ocean's depths have become a second home for
this elegant and swift underwater craft and its powerful
Voight-Kampff twin electric dynamo engines.

Le Calmar Géant by V&A Steamworks

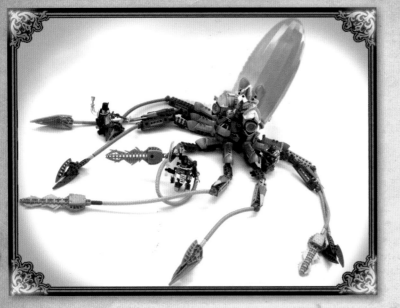

Le Calmar Géant was created to defend against the impending threat of underwater troops. The tireless mechanical arms are equipped with sharp cutting blades designed to sever enemy air supply lines (and limbs, I suppose). Nicknamed the "Tentacled Terror," it has yet to be placed into regular service for fear of its devastating and somewhat random method of operation.

This steam-powered submarine takes the form of a giant scorpion fish. The V&A engineers claim that by mimicking nature's preexisting piscine sensibilities, they have uncovered advantages previously hidden to mankind. Oddly, the ship did not begin its career with its current outlandish tropical paint scheme. The original colouring was a rather bland light grey, favoured for its ability to make the ship's ornate outer hull look more decorous in promotional literature.

Scorpion Sub by V&A Steamworks

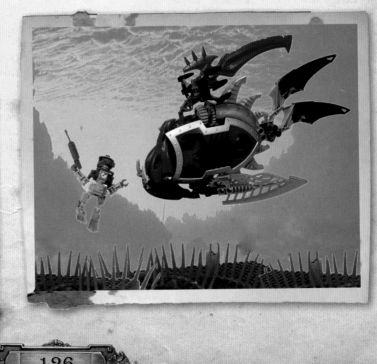

SHARK SUBMARINE
BY JAMES HENDRY

Often Mother Nature herself is the best source of inspiration for our aquatic engineers. These inspired yet highly treacherous vessels take their cues from the ocean's most dangerous denizens. This submarine's design allows it to scavenge fuel and parts from defeated ships and derelict wrecks and use the spoils to replenish its stores.

I wonder how it fares during mating season?

Lt. Penfold

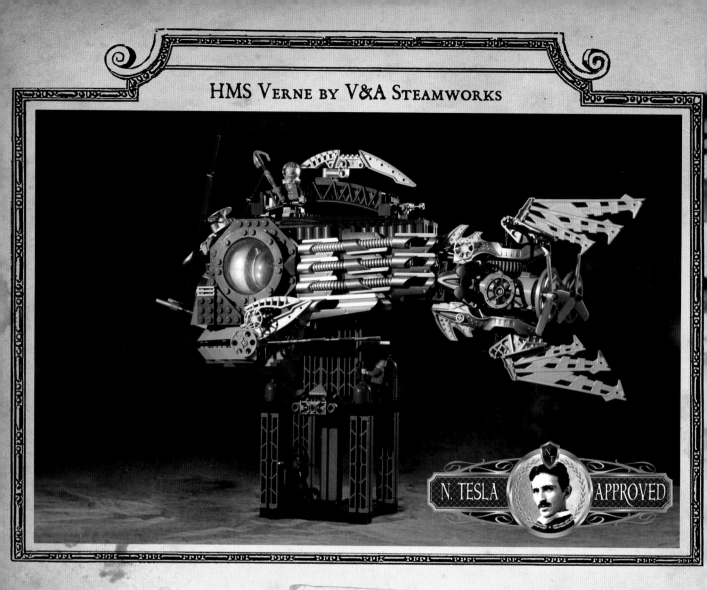

N. TESLA APPROVED

Built with a fishlike appearance, the HMS Verne bears striking aquatic details such as real pectoral dive plane fins, dorsal keel spines, and fish-scale reinforcement ribbing on its outer walls. One of its most dominant features is a forward-facing set of dual observation windows through which the crew can peer into the depths as they pilot this submersible craft on its missions.

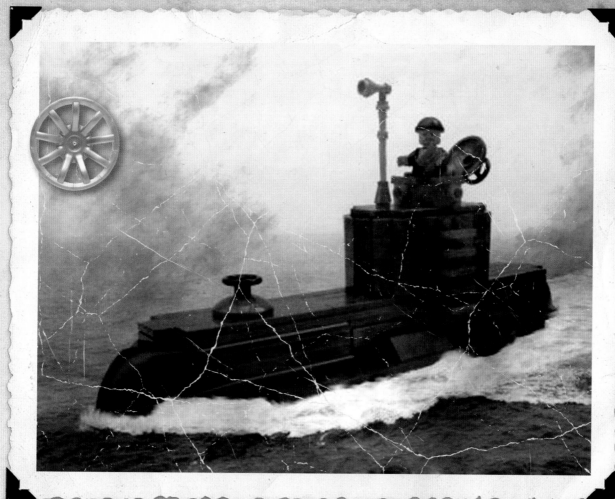

The Kaiser, increasingly frustrated by his country's inability to compete with the Royal Navy, gave his approval to increase the size and sophistication of his fleet of experimental submersible craft. The Ozeanräuber Mark III, pictured here in a rare photograph, was the result.

Although the Mark III could travel farther, faster, and deeper than any previous submersible in the Kaiser's fleet, it was never popular amongst his sailors. Constructed predominantly of wood, it was prone to leaking at even moderate depths and soon earned itself the nickname "das Wasserklosett."

2. November
Aboard Mr. Ssorg's Zeppelin —
floating above Newcastle-on-Tyne

Your Majesty,

Having conquered the oceans, we now set our sights on the skies.
I have witnessed grand flotillas of Dirigibles, belching smoke
and spitting steam as their massive airscrews pulled them through
wispy clouds. What a spectacle!

Passengers on today's flying machines travel in first-rate luxury,
within well-appointed staterooms. On the gangplank, the
aeronautical traveller is greeted with the familiar sights of spars,
sheets, and masts, but the alien additions of balloons, nacelles,
and colossal airbags signal that the expedition will lead to the
heavenly slipstream.

Military applications of the technology are well underway, too,
and allow for the swift delivery of devastating, rebellion-crushing
power upon the gentle winds.

My globe-trotting visits to these intrepid airship pioneers have
shown me that as the fleet grows, the world shrinks...

Your obedient servant,

Sir Herbert

AIRSHIPS AND DIRIGIBLES

"It is absolutely necessary
to know an operation will be
successful before proceeding."
—Hugo Eckener

THIS SPACE FOR WRITING MESSAGES

POST CARD

THIS SPACE FOR ADDRESS ONLY

PLACE
STAMP
HERE

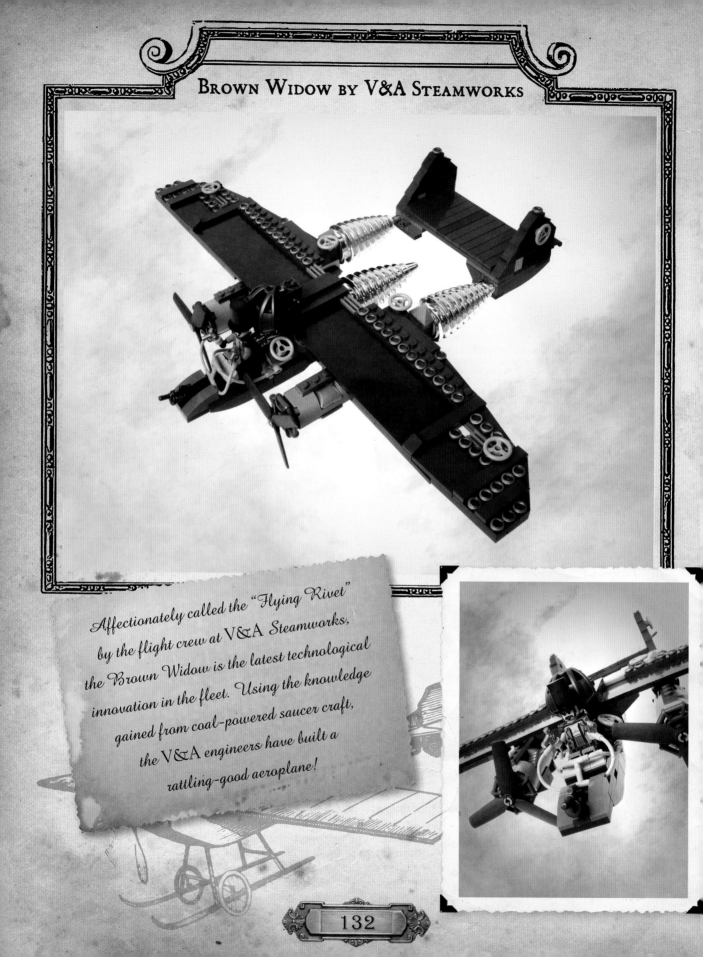

BROWN WIDOW BY V&A STEAMWORKS

Affectionately called the "Flying Rivet" by the flight crew at V&A Steamworks, the Brown Widow is the latest technological innovation in the fleet. Using the knowledge gained from coal-powered saucer craft, the V&A engineers have built a rattling-good aeroplane!

BLACK WIDOW BY V&A STEAMWORKS

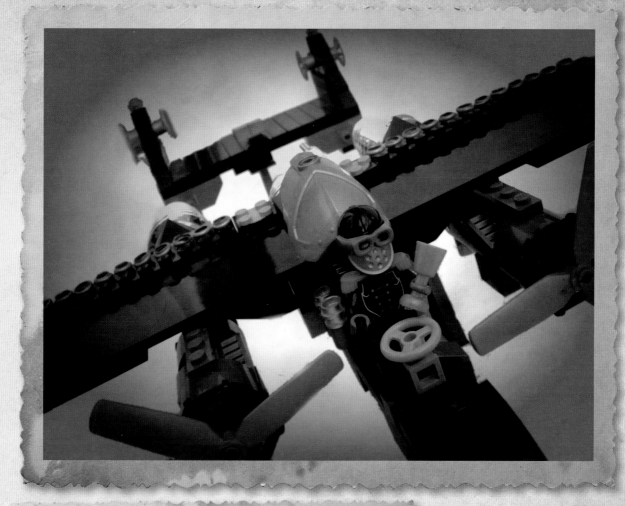

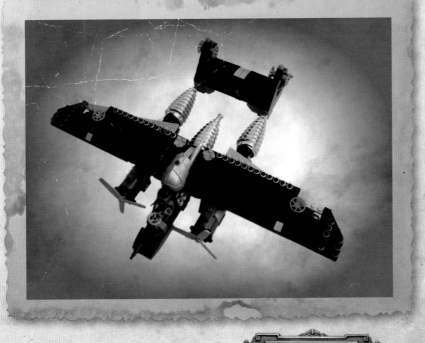

This is an alternative design to the classic Brown Widow. Some uppity arachnologist pointed out that the "black" version of the eight-legged beastie is apparently more common. Humph!

THE GOLDEN EMPRESS
BY V&A STEAMWORKS

The Golden Empress is so large that its shadow covers small villages entirely. Leaving massive air pollution in its wake, the colossal airship demonstrates the awesome power of the Qing Dynasty.

Though this airship is worrisome, I suggest we maintain an air of tolerant diplomacy for the sake of our interests in the East.

Lt. Penfold

The Golden Empress

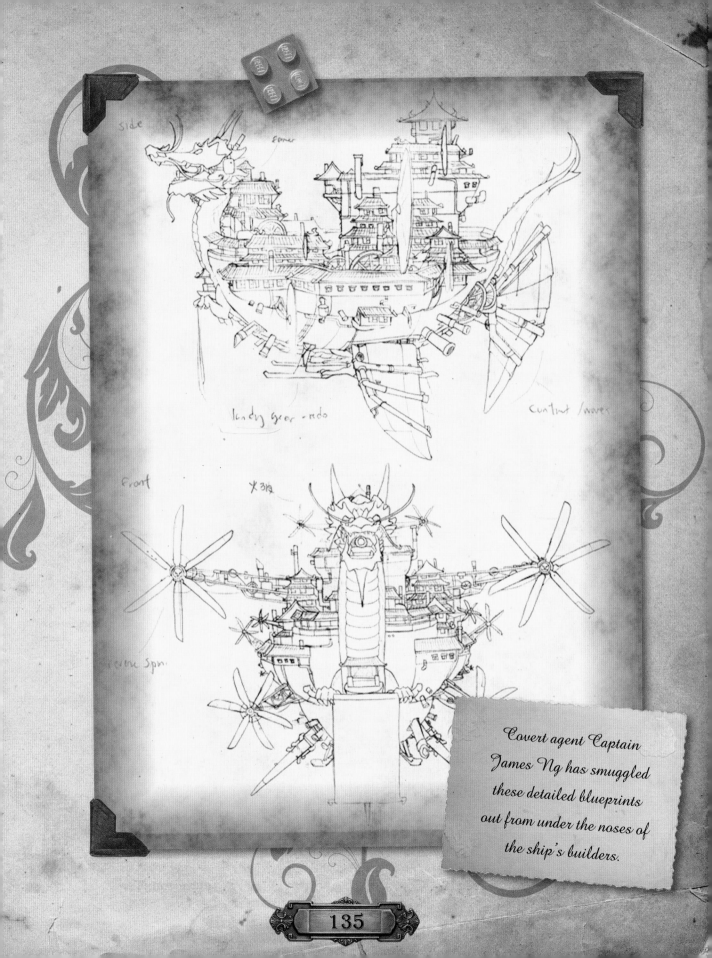

side

corner

landing gear - red

content /waves

Front

x 3½

reverse Spin.

Covert agent Captain
James Ng has smuggled
these detailed blueprints
out from under the noses of
the ship's builders.

SKY SCARAB
GUNNER CREW
V&A STEAMWORKS

SKY SCARAB
V&A Steamworks

Some have suggested that placing a giant ball full of explosive gas underfoot is hazardous! To those naysayers, the engineers at V&A Steamworks say, "Poppycock!" It has been rumoured that this ship's design was devised when the good ole boys in the Airworks accidentally placed the blueprints upside down, and voilà — the Sky Scarab was born!

Please be careful when landing
on sharp surfaces!

Lt. Penfold

136

LADY PUFFIN
BY KAHAN DARE

This nightmare of a craft is precariously balanced atop a sizeable helium balloon, and the twin rotors cut dangerously close to the main steering-wheel compartment. Many have argued that the whole craft was a rather idiotic endeavour, in that the crowded design of pipes and tubing barely allows space for the two pilots required for flight.

Further reports indicate that the pilots took off in a rather splendid fashion to, not surprisingly, their demise.

Lt. Penfold

This dangerous experiment in aeronautics was designed by The Daring Kahan. It makes about as much sense as a Zeppelin made of lead!

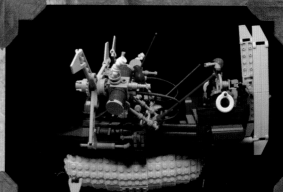

MISTRAL
BY NATHAN PROUDLOVE

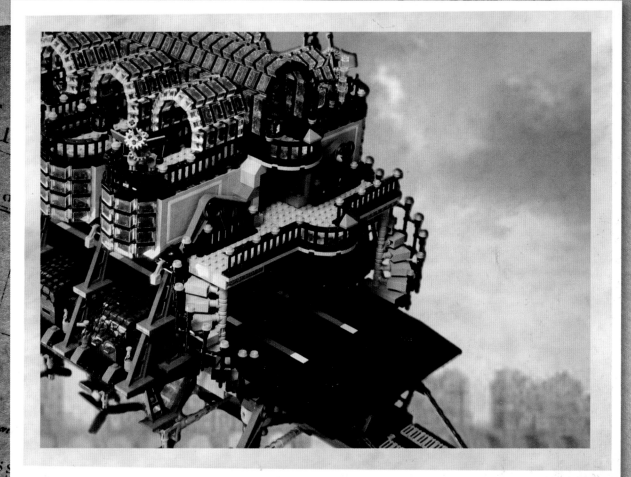

Air Marshal Proudlove is the gentleman behind the monumental undertaking known as the Mistral. Longer than a cricket field and as tall as a five-storey building, it is the largest aircraft ever built. Proudlove's worthy place in the pages of history was guaranteed when the hulking masterpiece took to the skies over the English Channel, flying high above the water at a speed in excess of 35 miles per hour. Although the Queen was pleased with the innovative design, the sheer bulk of the ship made it an impractical addition to the growing royal air-fleet. At present, the Mistral is scheduled to visit the shipping yards to be broken down for scrap metal. These are some of the rare photographs of the craft's maiden voyage.

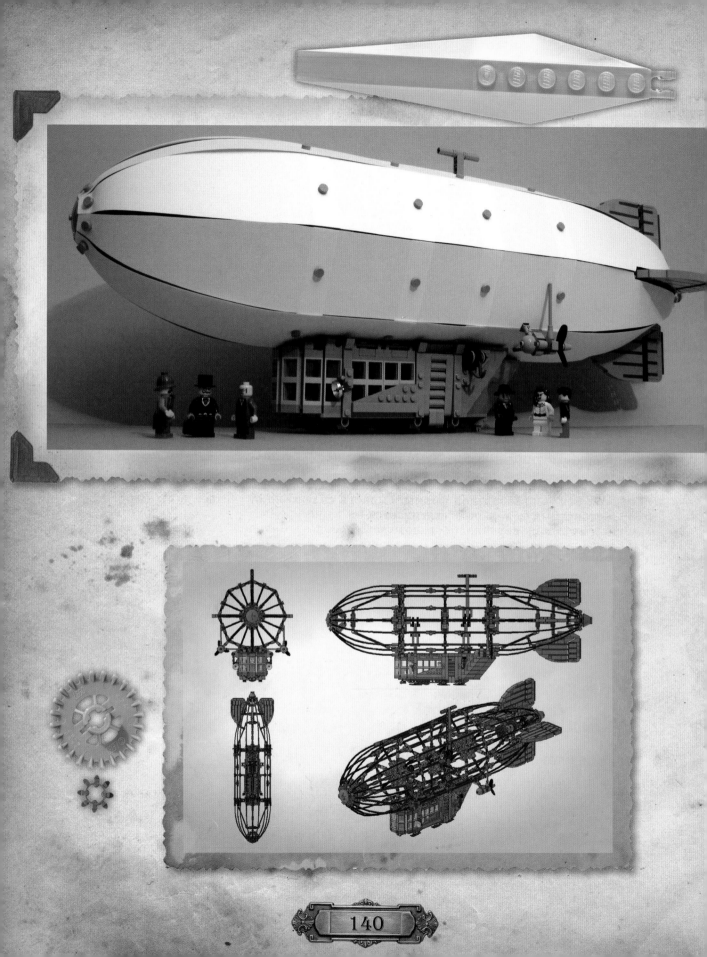

ZEPPELIN
BY SSORG

Count Ferdinand von Zeppelin is the father of the Zeppelin Balloon. When he saw the French flying their dirigible prototypes, he thought, "Germany must have this technology!" He embarked upon a years-long design and testing process with his world-famous society for aeronautics, the Gesellschaft zur Förderung der Luftschiffahrt, which I think translates to "Please don't smoke around the Hydrogen…"

J. ABBA'S LUXURY AIR BARGE
BY AMADO C. PINLAC

Sir J. Abba's Air Barge is a stunning sight to behold! On All Hallows' Eve, the crew dresses in fanciful costumes of unknown origin and consumes a meal composed of rare and endangered game from around the world! The spectacle might last for days, as the transport often takes extended trips through South Wales and the Scottish Highlands.

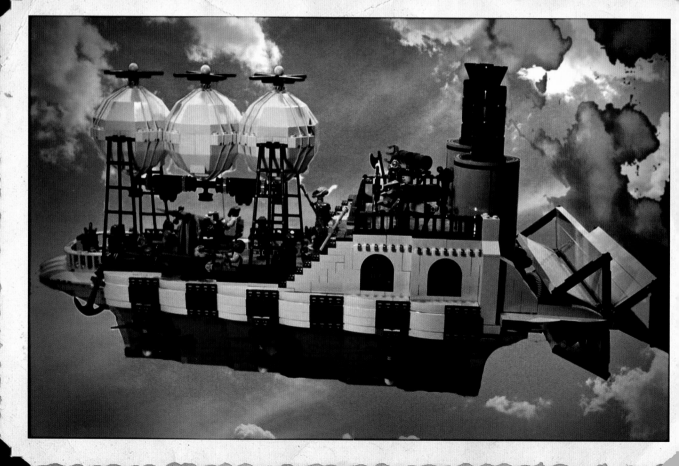

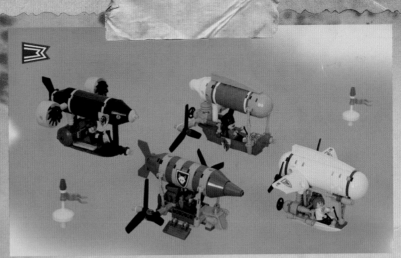

WestWinds Regatta by Ted Andes

Nothing warms my soul more than the sight of a flotilla of mighty ships floating across the grey skies of my homeland.

Sir J. Abba's appetites for wine, women, and song have become legendary throughout the Empire.

CHECKERED AIRSHIP
BY MIKE PSIAKI

Sir Dennistoun Burney has proposed a plan for a vast air-transportation service that will operate throughout the British Empire, using his highly advertised Checkered Dirigibles. They will be governed by the Air Ministry and are scheduled to convey passengers to India in the greatest of luxury. Since our Helium contract with the American Colonies is still being negotiated, the ships will use the miracle gas, Hydrogen!

Fig. III

144

FRS SHAKESPEARE
BY BARNEY MAIN

The ardent airmen who crew the Shakespeare work around the clock, week in and week out, to meet their lightning quota. The never-ending need for more and more electricity requires the crew to fill the ship's larder with enough supplies to sustain them on their long journeys through the clouds. Captains must find shipmates with nerves of steel and hearts of gold, for long journeys away from hearth and home have often been the ruin of men. "Lightning fishing" is hazardous work. In fact, Nikola Tesla was once quoted as saying, "I can think of no job more noble—nor more dangerous—than that of the lonely lightning trawler."

This majestic-class Lightning Catcher was created by Sir Barney of Londinium. Why pay for electricity when you can harness it from the very Heavens?

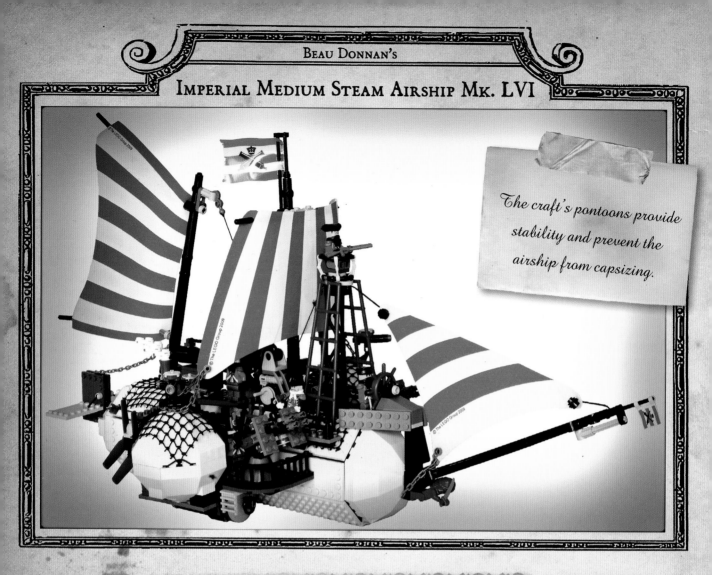

The craft's pontoons provide stability and prevent the airship from capsizing.

The Imperial Medium Steam Airship is armed with four 16 mm automatic rifles; two 20 mm quadruple-barrelled AA guns; and a 120 mm six-shot, rapid-firing revolving cannon used for ship-to-ship combat. The addition of sails gives this airship an unheard-of travelling range that is limited only by the provisions aboard the ship. Via clever usage of an internal steam boiler, air is compressed for long-term storage and can later be used to power the propellers, giving the airship an impressive burst of speed.

IMPERIAL MEDIUM STEAM GUNNER MK. IV
BY BEAU DONNAN

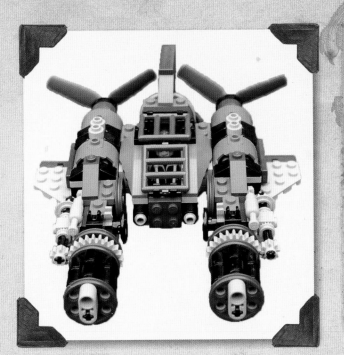

Possessing the accuracy of a fighter and the punch of a light bomber, this Gunner-Class flyer has become the backbone of the Royal Flying Corps. Designed to combat tenacious armoured ground forces, the Mk. IV comes armed with twin rapid-firing 20 mm guns and two six-shot 120 mm revolving cannons. Combat testing has also proven the Gunner to be quite effective against the newest class of heavily armoured Zeppelins.

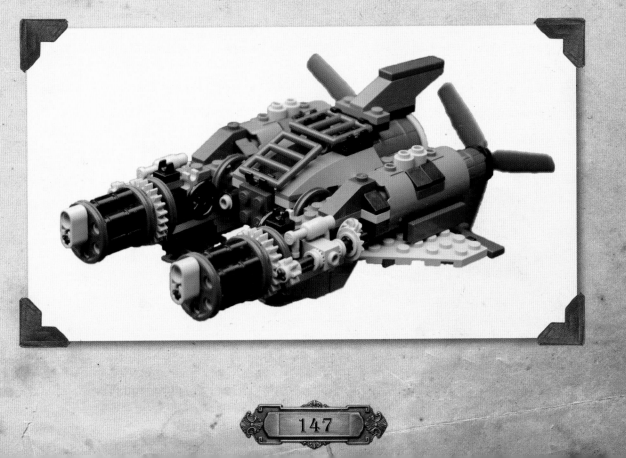

THE KAISER'S IMPERIAL LINE DIRIGIBLES
BY CAPTAIN SMOG MANUFACTORY

A panoramic point has been placed at the disposal of tourists wishing to enjoy the beautiful views.

The Kaiser's Imperial Line Dirigibles can take four passengers (plus the pilot) and fly at an admirable speed of 8 knots (without wind).

On the floating stop point, a photophone is used to communicate with technicians on the ground.

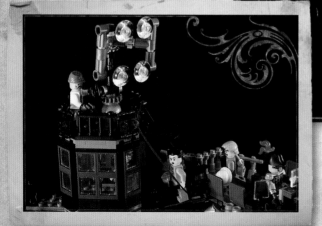

2Much Caffeine Motorworks

Certificate Of Award
Uniformity of Granulation

Scotland

The P2 Thunderbolt of the United States Air Cavalry roared into service in 1886. The first aircraft to successfully utilize the so-called "jet" steam turbine, the Thunderbolt was capable of astonishing speed.

Bringing the Thunder since 1886

P2 THUNDERBOLT

BENTLEY SKY PHANTOM

TUB FLYER

This photographic image shows Archibald Philip Primrose, the flamboyant Fifth Earl of Rosebery, at the controls of his beloved Bentley Sky Phantom.

It all makes sense, doesn't it?

One of the famous "Blue Cats" (Cruz Catalina Flying Boats) of the Floridian Independent Fleet Air Arm. These versatile attack craft were key to the FIF's position as the premier "Naval Force for Hire" in the early 1890s.

"BLUE CATS" OVER CUBA

SeaBee-23

The single-engined, single-seater SeaBee-23 was specially designed for aerobatic display.

LONDON–PARIS AIR RACE 1872
WINNER CAPT. LEWIS GALLOWAY
IN THE RACING SKIFF "RAMPANT"

The London to Paris Air Race has been held annually since 1836 and is the longest-running flying contest in the world. Victory in the London–Paris Race remains one of the most sought-after prizes in aeronautics. Captain Lewis Galloway is, without doubt, the Race's most famous champion. Winner on no fewer than seven occasions, he still holds the record for consecutive wins with five in a row—all of them in his world-famous racing skiff, Rampant. His final victory (in 1872) was awarded posthumously, as his flaming craft plunged across the finish line beneath the Arc de Triomphe only seconds before erupting in an enormous fireball.

THE KINROSS P.A.C. MODEL 1

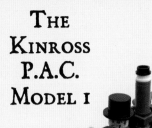

The Personal Aeronautic Conveyance, manufactured by 2MC Motorworks of Edinburgh, was one of the vehicles that drove the boom in private aircraft ownership during the 1850s. It was a robust craft, famed for its ease of maintenance and low running costs.

VON KRIEGER'S FLUGMASCHINE

Von Krieger's Flugmaschine, once considered the most dangerous aircraft ever made, is now the yardstick by which aviation safety and reliability are measured.

10. December

Mecha Kaiju Fight Club

(location not to be spoken of!)

My Queen,

Mother Nature is the inspiration behind this collection of mechanical marvels. Arrayed before Your Majesty is a clockwork zoo of invertebrates and insects, crustaceans and creatures.

Keen observers have noted that the most efficient designs are inspired by natural systems. A fleet of robotic predators may one day do the work of an army of soldiers.

And yet, the creatures I've discovered are suitable for much more than warfare—I've found pets and familiars of all types, some suitable for espionage and still others mere curiosities.

Yours in service,

Sir Herbert

CLOCKWORK BEASTIES

PLACE
STAMP
HERE

"[Animals] are destitute of Reason, and...
it is Nature which acts in them according to the
disposition of their organs: thus it is seen, that a
clock composed only of wheels and weights can
number the hours and measure time more exactly
than we with all our skill."
—René Descartes

HMS SHELMAN
BY V&A STEAMWORKS

This crabby conveyance can travel freely upon sandy shores and beachhead battlefronts. The Shelman's wide, flattened shape allows it to take advantage of holes and crevices in the terrain to take shelter from projectiles launched by enemy forces.

Its eight legs and two large, powerful claws work in conjunction to allow for articulated grasping and fighting. The legs bend in such a way that the machine must scuttle in a sideways manner. Protected by a hard mottled brown exoskeleton, the crab can burrow into the seabed with the top of its shell just visible, to further shield the underside of its body.

THE ROYAL ROACH
By Zach Clapsadle

This insect-like robot is based on that most tenacious of vermin, the German Cockroach. Although the inspiration for its construction is less than noble, its applications could be quite extraordinary! By mimicking insect locomotion, this clockwork pest can scurry about with impressive stability and manoeuverability. Imagine a swarm of these dropped into an enemy's base camp!

The enemy would "bug out" indeed!

Lt. Penfold

CLOCKWORK LIONFISH

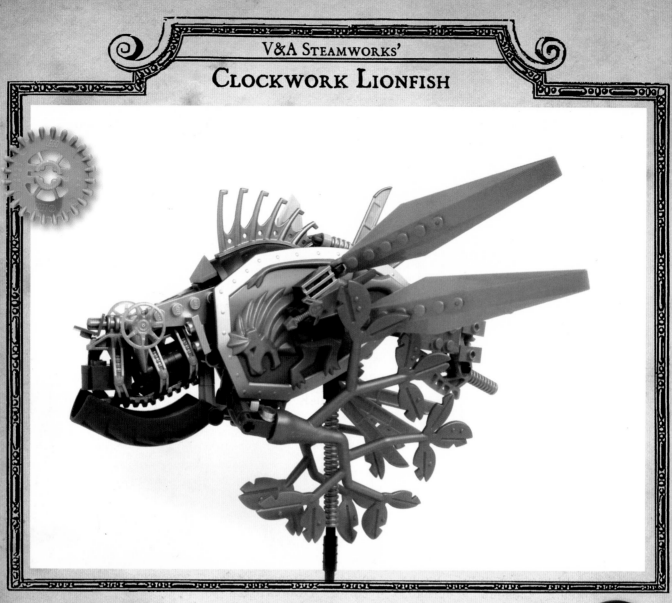

An early success in underwater
automation, the Lionfish
helped V&A Steamworks
win Your Majesty's coveted
Medal of Merit in the field of
clockwork innovation.

THE SKEETER
BY NATHAN PROUDLOVE

Part of Proudlove's "bugs of war" program, the Skeeter uses a number of design innovations to imitate this familiar pest's particular mode of flight. Its dueling gearboxes, when operating in harmony, move the Skeeter forward and back and, when working in opposition, turn the bug clockwise or widdershins! Truly smashing! Combined with its cantilevered wings, this flitting ability provides the pilot with an unrivalled manoeuverability in flight.

WARCLAW
BY LUKAS WINKLER PRINS

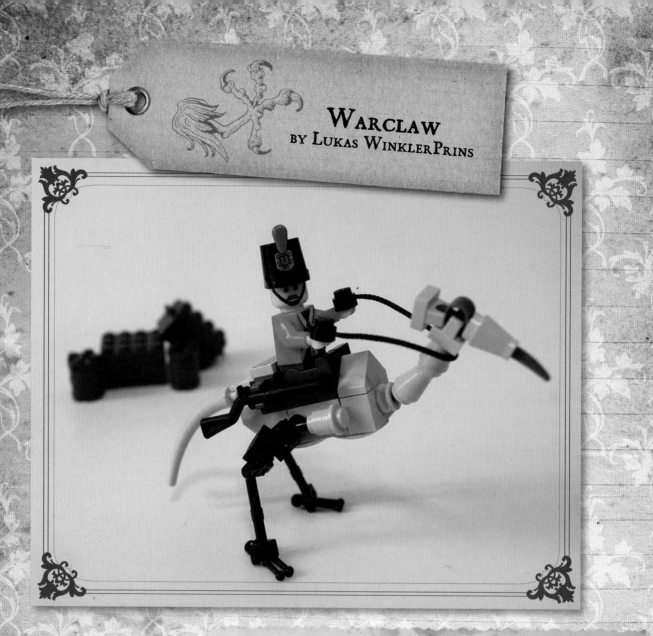

To test their mettle, the jousting knights of Buzzard Squadron mount their flying mechanical steeds and collide with one another high above their platformed base at Ivanhoe Peak. Air Commander William Pfutzenrueter of the Winged Air Cavalry is the undefeated champion of the jousting arts. As the cavaliers play at war, their steeds' wings furiously flapping, the elevation of a challenger's lance in relation to his opponent's weapon determines the outcome of the noble contest.

THE AMBLER
BY KEVIN RYHAL

The Ambler is constructed with a double-decker passenger section capable of holding a full complement of troops. This quadruped walker can traverse uneven terrain at an impressive 60 kilometres per hour.

Tinkerers and Brave Scientists compete in secretive robot battles called "Mecha Kaiju Fight Club!" The roster of the M.K.F.C. is a highly guarded secret, as this type of activity is frowned upon by much of proper society.

M.K.F.C.
BY V&A STEAMWORKS

Here we see two of M.K.F.C.'s anonymous members.

Mighty animal-themed mechanical dreadnaughts clash to display their impressive and varied arsenals of staggering firepower. Typically, the beasts' control systems are placed in the resilient, armored chest region instead of the head (as heads are often cleaved off during the violent battles).

CLOCKWORK WYRM
BY V&A STEAMWORKS

When V&A Steamworks received a commission to build a clockwork horse for a wealthy patron who had grown weary of shovelling "road apples," those impetuous chaps in the design department decided to make something…bigger. In truth, they're too clever by half.

Sir Herbert, this device looks quite difficult to wind!
Lt. Penfold

CLOCKWORK OWL
BY ANDREW LEE

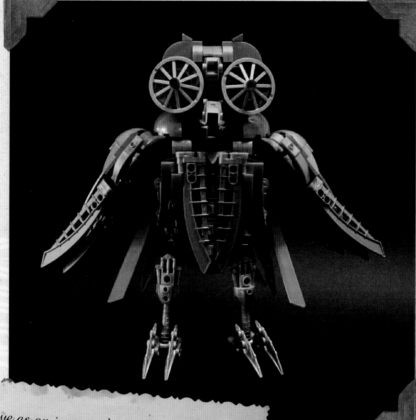

Built to serve as an inventor's companion, this amazing construct was inspired by the work of the legendary and world-renowned Admiral R. Harryhausen. This mechanical owl is affectionately called "Bubo," and though it is not capable of true flight, it can flap its golden wings about whilst parroting a riddle via a recording played from deep within its ball-and-socket workings.

By activating a secret button, one can project a star map from the owl's eyes to show the constellations of Perseus, Andromeda, Pegasus, and Cassiopeia.

5. January

La Maison de Champagne — sharing a glass of Sherry

Your Majesty,

Gravity is a troublesome business; it makes apples fall and Ornithopters crash. Yet through liberal application of Cavorite, the experimental weight-negating element gaining popularity within our SPACE! Division, rocks can be transformed into granite balloons.

Unburdened by the embrace of gravity and free to glide about, these mind-boggling floating structures can play the role of fortress or farmhouse, manor or metropolis. Some drift at the mercy of the winds, but the more sophisticated of these sky-sailing mountains can be piloted, thanks to the addition of steam turbine engines and propellers.

These curious floating worlds and their denizens, loosed as they are from terra firma, present an interesting diplomatic challenge. I shall attempt to discover which, if any, earthly nations they might ally themselves with.

The real trouble with these chaps is their lack of permanent mailing addresses. Tracking the location of these properties has proven an imperfect science at best.

On that note, perhaps a stringent requirement for floating lighthouses may be in order?

Your servant,

Sir Herbert

The Postmaster has some grave concerns as to the delivery rates for parcels to these locales!

Lt. Penfold

FLOATING ROCKS

SPACE FOR WRITING MESSAGES

POST CARD

THIS SPACE FOR ADDRESS ONLY

PLACE
STAMP
HERE

"My atom simply failed to fall.
If an atom could be suspended
indefinitely, well—why not an
apple? If an apple, why not a city?"
—Rosalind Lutece

The Floating House is the home of an elderly widower whose dream is to float his house all the way to the legendary Falls of Paradise in untamed South America. This house uses a Hydrogen balloon to complement the lifting capabilities of a partial Cavorite application.

FLOATING HOUSE
BY THÉO BONNER

Fig. III
168

PEACEFUL ROCK
BY TYLER CLITES

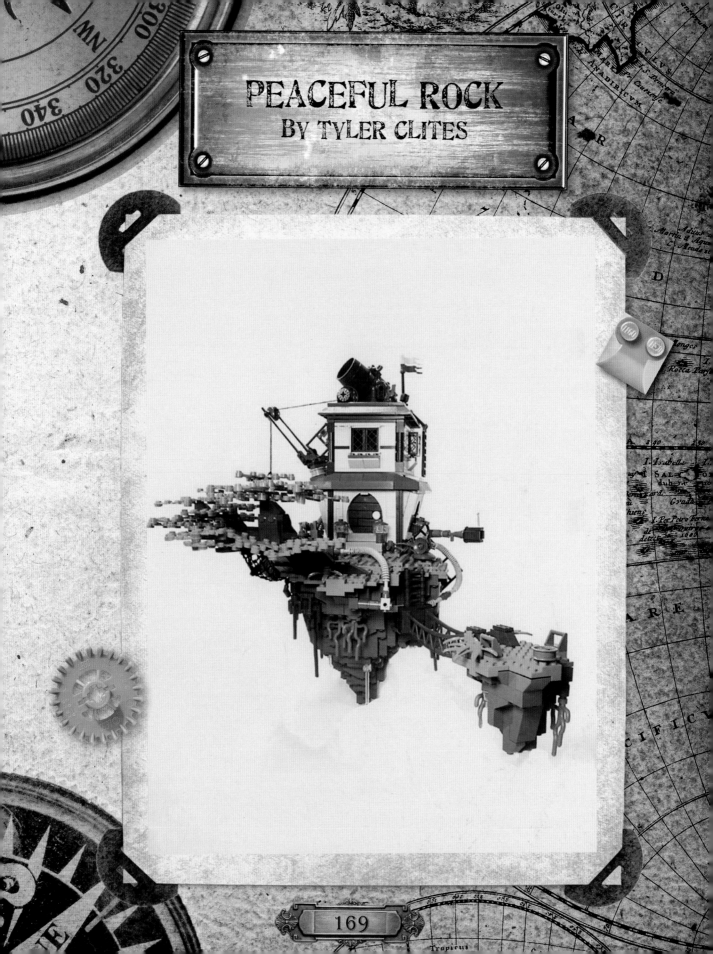

A strange history follows this chunk of floating earth. The town perched upon it was the earliest manufacturing site of the Cavorite element. Sadly, due to some haphazard manufacturing processes, a generous amount of the experimental material leached into the surrounding groundwater and resulted in the entire township taking to the air!

LAST EVACUEE BY BARNEY MAIN

As this accidental foundation has fractured away and the land mass has withered and crumbled, bits of the town have either shot upward into the heavens (never to be seen again) or fallen, often with disastrous results, to the countryside below. Now, only the mayor's office remains. He lives there alone, perhaps intending to "go down with his ship."

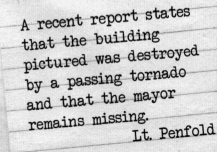

A recent report states that the building pictured was destroyed by a passing tornado and that the mayor remains missing.

Lt. Penfold

THIS SPACE FOR WRITING MESSAGES

POST CA**R**D

THIS SPACE FOR ADDRESS

LONDON 3739
No. 43

Rumours...a battle-hardened soldier such as myself has little patience for them. Yet...on more than one occasion, it has been suggested that the architect of this lighthouse is not quite right in the belfry. Nicknamed "The Chief," he is, according to some, actually a robot in disguise! Lend no credence to these old wives' tales; I have met the young chap, and he seems fit as a fiddle, except for an odd affliction that occasionally makes his eyes glow red.

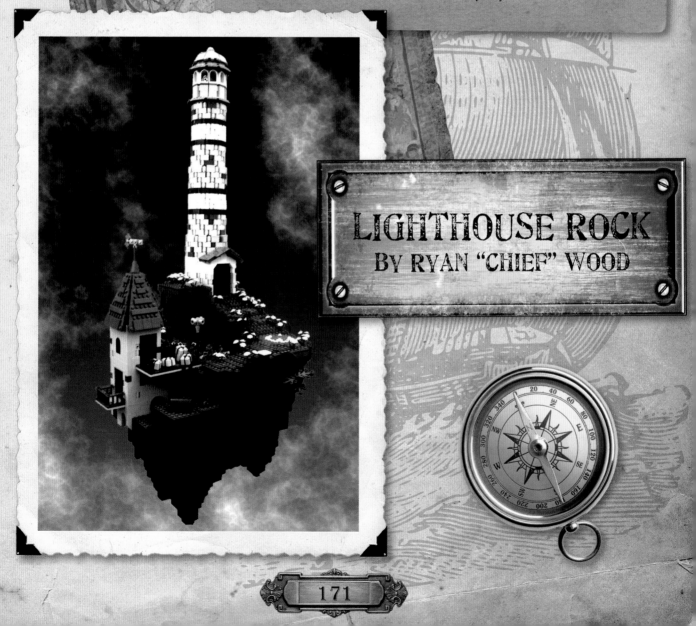

LIGHTHOUSE ROCK
BY RYAN "CHIEF" WOOD

LOST ROCK BY LAZLO KISSIMON

Baron Clemenza of Toortopia is the ill-tempered and peculiarly dressed captain of this mismatched and bizarre floating rock. When I met the Baron, he spent many hours rambling about his family's vast fortunes, which were lost along with his copper-plating business. My assessment is that His Lordship possesses no real sense of direction and prefers spending his life floating from city to city in a desultory manner as he goes about trading bits of scrap metal and other industrial detritus. I declined to purchase a bottle of his "Cure-All" potion. I have seen Snake Oil before.

Monsieur Duval is a great investor and patron of the arts. Notably, he owns shares in a coal mine in Wallonia and in the New York/Saint-Nazaire Zeppelin Company. When he is not in his mansion in Lille, he likes to relax with his family in his floating country house, a charming manor surrounded by a spotless garden. Here, life takes its course peacefully: the post arrives by airship, Nestor the butler mows the lawn, and the views are magnifique.

LA MAISON DE CHAMPAGNE

BY THÉO MORIER

Under the rock lives an artist who has isolated himself, looking for inspiration (or perhaps to escape his creditors).

POLAR OUTPOST 7: LIGHTHOUSE & ARCTIC RESEARCH STATION
BY TED ANDES

This is one of 27 outposts placed along the "Northwestern Wind Stream," a trade route through the Arctic. The Intercontinental Airship Alliance originally established this network of beacons to provide safer passage through the treacherous archipelago of floating rocks and crosswinds.

The Arctic Explorer's League volunteered to man these remote outposts in exchange for being allowed to conduct their research. The Airship Alliance agreed to this mutually beneficial arrangement, in addition to providing for the necessary delivery of supplies.

TELEGRAPHY ROCK
BY DREW ELLIS

Belonging to Alfonse "E.T." Dover, this telegraphy installation has a less-than-terrestrial feeling about it. Although it bears the mark of Earthly construction, some of the landscaping seems almost otherworldly in size and shape. Strangely, I have not seen any evidence of Hydrogen airbags or of the application of Cavorite on the underside of the foundation to explain its ability to float.

ROCK&ROLL

The Rock & Roll Good Conduct Medal is awarded by Queen Victoria to builders who served with excellence in the Rock & Roll Steampunk LEGO campaign.

Wear your medal with pride!

After many years, Alfonse still hasn't been able to contact his home...

Lt. Penfold

Aboard the Falcon of the Millennium — discussing chivalry

Your Majesty,

While it is true that your great Empire is so vast that the Sun never sets upon it, your loyal subjects have hitherto been confined to the terrestrial limits of Earth. I am pleased to tell you that these days are no more!

It has long been suggested that Steam technology offers the promise not only of an unlimited supply of hot water for Tea but also of the power for space travel. To explore this theory, I called upon the esteemed scientist, Nikola Tesla, who shared with me an enlightening discourse regarding the many technologies, hitherto secret, that shall soon power a space-bound armada.

According to Mr. Tesla, recent developments in the sciences will allow our armies access to the very Moon and Stars. Diligent inventors have created such wonders as Aetheric Generators, Magnetic Balloons, Buoyancy Rays, and Propellers for navigating the Luminiferous Aether. Although these strange and novel craft work by mysterious means, I have been assured by none other than Dr. J.W. Keely that the science is as sound as the British Pound.

Scientists have also discovered a curious element called Cavorite, which — when applied correctly — can allow any object to float free from Earth's grasp. These varied technological advancements all hold the promise of propelling flying machines across the Open Seas of Space.

Indeed, with these machines, we can now attack the Martian invaders before they dare set their scaly reptilian feet upon our green and fertile lands!

Your servant,

Sir Herbert

"Science, my lad, is made up of mistakes, but they are mistakes which it is useful to make, because they lead little by little to the truth."
—Jules Verne

SPACE!

He jests, my Queen. We would need oxygen pills first. Although surely these, too, cannot be long in coming!

Lt. Penfold

X-RAY FIGHTER
BY SEAN JENSEN

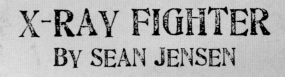

IMPERIAL COACH
BY SIMON LIU

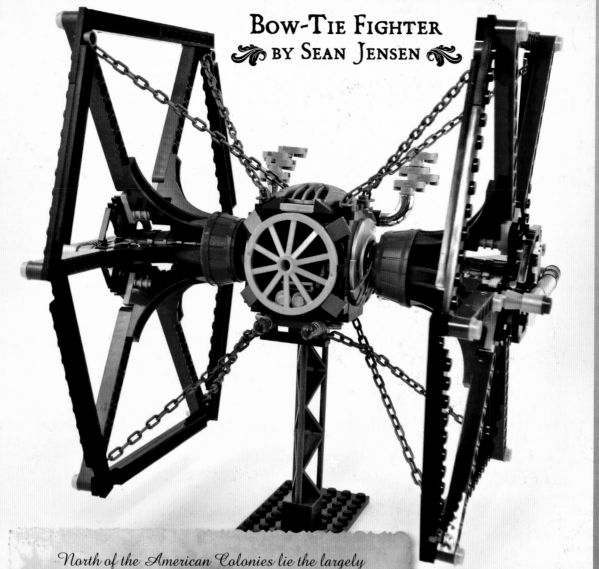

BOW-TIE FIGHTER
❧ BY SEAN JENSEN ❧

North of the American Colonies lie the largely
frozen lands of Canada, fertile hunting ground for
giant white Ice Bears as well as fruitful territory for
space-travel researchers. The tinkerers at the secretive
Poutine Laboratories have designed a fleet of ships
that use Buoyancy Rays and Magnetic Balloons
to voyage beyond Earth's atmosphere. The builders
felt it unwise to explain the theory behind these
technologies but assured me as to their integrity.

LETTER-WING FIGHTER
BY LARRY LARS

The liberal application of Cavorite to the underside of this ship allows it to ignore the restraints of gravity! In effect, the nature of the Cavorite causes the ship to fall off of the Earth and into Space, as though the normal order of up and down were reversed.

It has been explained to me that earlier test vehicles were not chained to the hangar floor, and hence they were lost to the Heavens upon application of the Cavorite (the Cavorite itself was also lost in this devastating fashion). Clearly, the prospect of space navigation is in its infancy.

FALCON OF THE MILLENNIUM
BY CHRISTOPHER DOYLE

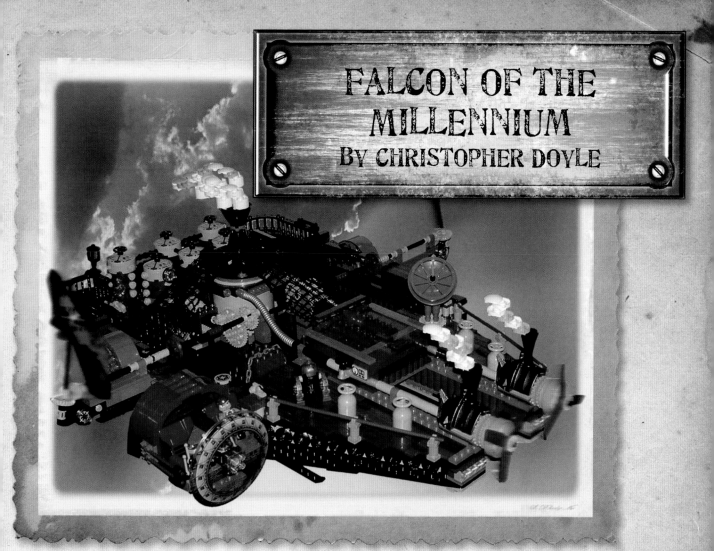

WATER TANKS

BOILER

STEAM FEED TO FRONT PROPS

PISTON (1 OF 2)

DRIVE SHAFT FOR SIDE PROP

I met the captain (more than likely a duffer) of the Falcon of the Millennium at a local flash house frequented by pickpockets and bit fakers. The rakish aviator had already been partnered with an unfortunate giant Hirsute acquired from a passing circus sideshow. Though mute, the furry giant growled at me several times during my dealings with the Falcon's captain.

MERLIN MK. I AND DOOMSDAY ROCKET
By Tyler Clites

In the Southern swamplands of the American Colonies, the mad visionary Professor T. Clites rivets together space-faring ships that harness the power of the Aetheric Generator. An interior propeller or screw uses the Handwavium Principle to convey the ships, at high speed, through the invisible fluid oceans of Aether that quietly surround us. Although I haven't seen the ships in flight, Dr. Keely has assured me that Prof. Clites's work is up to snuff!

STEAM VIPER
BY V&A STEAMWORKS

Built with a mind toward defence, this ship would deal exclusively with aggressive robot men from the future. The threatening nature of these clanking, mechanical star-men has yet to be determined, but the large barking cannons mounted on the Steam Viper's awe-inspiring bow seem more than capable of thwarting any treacherous invasion from SPACE.

HMS MOONDREAMS'S VOYAGE TO THE MOON
By V&A STEAMWORKS

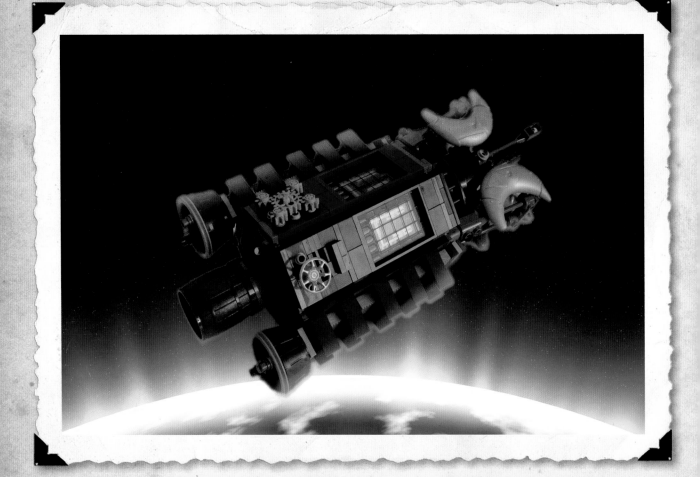

This fanciful design proposes the "shooting" launch of the HMS Moondreams via a titanic cannon! While an imaginative idea, perhaps this is a plan more suitable for a performance at the local theatre than for a test of aeronautic theory. I will have to enquire into the outcome of this venture on a future visit.

Astronomer Garrett P. Serviss has painted these exclusive and probably fanciful illustrations of the HMS Moondreams in flight over the Moon.

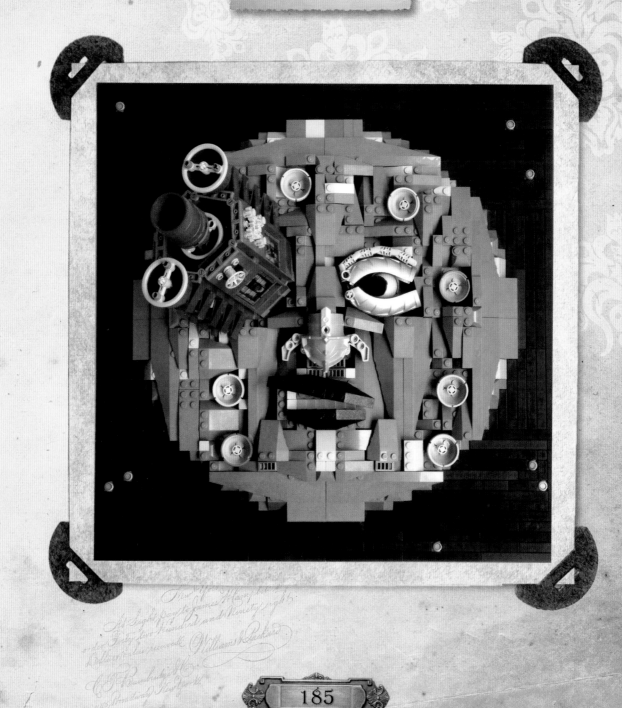

Here we see a vision
of the ship's arrival at
some distant port.

CONTRIBUTORS

All copyrights retained by the individual copyright holders.
Photos marked with an asterisk are copyright Guy Himber.

Amacher, Sylvain ("captainsmog"), *www.flickr.com/ photos/captainsmog/*: The Annihilator, 95; Der Goliath, 33; The Kaiser's Imperial Line Dirigibles, 148; Shrapnell Automaton, 80; Steaminibot, 108*; The Steamobile, 63; Steamonowheel, 34–35; The Über Zerstörer, 62; Urban Steam Monorail, 14

Andertoons: The Red-Eyed Centurion, 67

Andes, Ted: Cornwall Cannonball, 6; Newcomb's Folly, 11; Polar Outpost 7: Lighthouse & Arctic Research Station, 174; WestWinds Regatta, 143

Andrews, Aaron: Troll Crusher, 66

Armstrong, Matt ("Monsterbrick"): MB No. 3 Phonograph, 87; MB No. 5 Chest, 86; MB No. 7 Telephone, 88; MB No. 8 Telegraph, 86; MB No. 9 Telephone, 87; MB No. 12 Typewriter, 86; MB No. 22 Camera, 88; Monsterbrick's Derringer, 89; Sewing Machine, 87; Top Hat, 85;

The Artful Badger: The Badger, 108*

Asanuma, Mariann: Micro Taj, 109*

Baer, Blake: Scientific Scales, 98

Baron Von Sterling: Fire of Innovation, 106*

Baixinho, Luis: W8, 31

Berkoff, Micah ("Arkov"): Boiler Knight, 81; Model 1858 Remington .45, 99; Punkfish, 56; Ragdoll, 108*

Bikics, Milán: The Pee-vil, 105*

Blaq, Cole: Tagger, 105*

Bonner, Théo: Floating House, 168; Roboticus, 104*; Sir Biggles, 72; Steamikoma, 43; Worthington and Smith, 41

Brick Dynamics: Lightning Saber, 98

Brixwerx: Fire Buggy, 109*; Lenses of Seeing, 108*

Cacioppo, Eric: Steamcycle, 30

Clapsadle, Zach: Calloused Boxer, 53; The Royal Roach, 157

Clites, Tyler: Draken Music Box, 106*; M-6 Protectotron, 74; Merlin Mk. I and Doomsday Rocket, 182; Peaceful Rock, 169; Proud Larry, 75; Tripodi, 50; Undersea Steam Explorers, 114–115;

Countess Sterling: Micro Hogwarts, 105*

Dare, Kahan: Lady Puffin, 137

De Blöd, Guss: Mystery Ship, 116–117

De Dobbelaer, Bart: Espace, 109*; HEX Walker, 58

DeGobbi, Dave: Crawler Town and Salty Town, 46–47; Micro Crawler Town, 107*

Donnan, Beau: "Armada-Class" Heavy Steam Railship, 17; Far Eastern Light Steam Tank, 20; Imperial Medium Steam Airship Mk. LVI, 146; Imperial Medium Steam Gunner Mk. IV, 147; "Ironclad-Class" Light Double-Gauge Steam Railship, 19; Jörmungandr Class Double-Boiler Locomotive, 15; Light Steam Landship, 16; Light Steam Transport Vehicle, 20; "Shunter-Class" Light Steam Railtug, 18; "Titan-Class" Double-Boiler Locomotive, 21

Doyle, Christopher, *http://reasonablyclever.com*: Falcon of the Millennium, 181

Dr. Mobius: Zorak Cranium, 102*

Druon, Eric ("BaronSat"): Steam Speeder, 59

Edwards, C.J.: Island of Micro, 106*

Ellis, Drew: Diving Belles, 10; Telegraphy Rock, 175

Eylar, Alex: Check Your Box, 105*

Field Marshal Lino: Head of JuJu, 107*

Gachod, Vincent: Machine No. 1, 44; T6-Clanker, 45

Gilliam, Micah: GFOL, 109*

Gillies, Rod ("2 Much Caffeine"): American Zephyr, 26; Bentley Sky Phantom, 150; Blue Cats, 151; Device of Infinite Peril, 102*; Doctor Hightower's Personal Engine, 27; HMS Atlantica, 125; HMS Nautica, 122; The Iron Duke, 77; The Kinross P.A.C. Model 1, 153; The Nautilus, 113; O'Neill's Mini Submarine, 124; Otto the Ottoman Automaton, 76; Ozeanräuber (Ocean Raider) Mark III, 129; P2 Thunderbolt, 150; Rampant, 152; SeaBee-23, 151; Tub Flyer, 150; Victory, 118–119; Von Krieger's Flugmaschine, 153; Vulcan, 112; Wunderkammer Larva, 108*

Gould, Tim: Little Morris, 108*

Hammerstein NWC: Queen's Hammer, 73

Heath, Iain: Bast Idol, 102*; The Chained Book, 107*; Controller Ultimo, 102*; Idol of Anubis, 104*; Jade Statue, 107*; Time Machine, 102*

Hendry, James: Shark Submarine, 127

Herr Ware: Mosaic Orange, 108*

Herzberg, Felix: Catching Rocks, 9; Clockwerk Express, 8

Higdon, Deborah: Poetry of Bees, 102*

Himber, Guy ("V&A Steamworks"): Albinus Curio Cabinet, 101; Black Widow, 133; Braveheart Disruptor, 90; Brown Widow, 132; Clockwork Lionfish, 158; Clockwork Wyrm, 164; Crown Royale Infinity Rifle, 94; Edison's Bane, 5; Gear Makes the Man!, 91; The Golden Empress, 134–135; Hand of Vecna, 102; HMS Moondreams's Voyage to the Moon, 184–185; HMS Shelman, 156; HMS Verne, 128; Le Calmar Géant, 126; Mini Wunderkammer, 104; M.K.F.C., 162–163; Orrery, 93; Penny-Farthing, 24; Robot Research Labs, 70–71; Scorpion Sub, 126; Sky Scarab, 136; Steam Viper, 183; Tesla Man-Machine, 68–69; Tesla's Pigeon Pistol, 92; The Victoria Steam Carriage, 55; Wunderkammer, 101;

Hussey, Wayne: Wayne Wagen, 103*

Jackson, Simon: Steam Prancer, 51

Jensen, Sean: Bow-Tie Fighter, 179; X-Ray Fighter, 178

Kescenovitz, Brian: Blue Orpington, 54

Kissimon, Lazlo: Baron Von Batten's Train, 7; Lost Rock, 172; Von Bentlee, 40

Labuguen, Norbert: Green Power Ring, 109*
Lars, Larry: Letter-Wing Fighter, 180
Lee, Andrew, *https://flickr.com/photos/wintermute2600*:
 Clockwork Owl, 165
Liu, Simon: FerreroPod, 109*; Imperial Coach, 178
MacLane, Angus: CubeDude Anatomy, 109*.
 "CubeDude" is a registered trademark
 of Angus MacLane.
Main, Barney: FRS Shakespeare (as featured in
 The LEGO® Ideas Book, Dorling Kindersley,
 2011), 145; Last Evacuee, 170
Malloy, Chris: Vern's Blight, 107*
Maulfair, Matthew: Castle of the Wee Loch, 106*
Mayo, Sean and Steph: Wardrobe, 106*
McIntire, Gary: Caged Fiji Mermaid, 107*
Meno, Joe: Bilund Cylinder, 103*
Merriam, Carl T.: Monsanto Might Microscope, 104*
Morier, Théo ("Theolego"): La Maison de
 Champagne, 173
Neumann, Mark: The Gun, 108*
Ng, James, *http://www.jamesngart.com*: Imperial
 Airship, 135
Oohlu, Karf: The Infernal Croaker, 108*; The
 Velocichopper, 25
Pinlac, Amado C. ("ACPin"): J. Abba's Luxury Air
 Barge, 142–143
Plums Deify: Ark of Bast, 103*

Prof. Heather: House of Heather, 104*
Prof. Ley Ward: Splorp, 104*
Proudlove, Nathan: The Boneshaker, 60; Fiji
 Mermaid, 105*; Kaptain Kazoodle and the
 Travelling Circus of Doom, 61; Mistral,
 138–139; The Skeeter, 159
Psiaki, Mike: Checkered Airship, 144
Ras, Ruben: Dr. Schweitzer's SW - Physeter I, 123
Reid, Peter: Chelonian, 107*
Rinker, Brian: The Five Points Wheel, 36
rongYIREN: HumanoidBOT, 104*
Rybak, Piotr ("lomero"): Hedgehog, 42
Ryhal, Kevin ("Moodswim"): The Ambler, 161
Sabath, Dan: R.A.C.E.R., 28–29
Sava, Tony: Model 7244, 4
Schmidt, Pascal: Mark IV Self-Propelled Artillery,
 12; Pirate Rail, 13; Railcastle Defender
 Engine, 12; Royal Steamonotrack, 32;
 Steam-Powered Lamp, 105*
Schwab, Florian ("demdike"): TerreQuad, 52
Schwartz, Jordan ("Sir Nadroj"): Fulton's Revenge,
 120–121; The Mole, 57; Pork Chop, 107*
Shannon Ocean: Anomalocaris, 103*
Spencer, Jamie ("Morgan19"): Dardenbahst, 49;
 Kriegerhund, 48
Ssorg: Zeppelin, 140–141

Sterling, Dave ("Lord Sterling"): Lord Sterling's
 Entropic Molecule Disruptor, 96; Lord
 Sterling's Rifle, 96; Miss Donovan's
 Farnsworth, 97
Walker, Katie: Laughing at Gravity, 105*
Wedin, Josh: Friendship Faerie, 109*
Williamson, Tommy: Electroionic Discombobulator,
 84; Obscura, 108*
WinklerPrins, Lukas ("Gladius"): Warclaw, 160
Wood, Ryan "Chief": GIR, 107*; Lighthouse
 Rock, 171
Yrizarry, Nelson: General Greeves' Amazing Wheel
 Bike, 37
Zarki, Tim: Iron Brawler, 78; Oculus Dive Suit, 79
Zhang, Nannan: BlackPod, 105*; Mini Black
 Fantasy, 104*

Stock Photo Credits

And we, reposing especial trust and confidence in the loyalty, ability, and judgement of our right trusty and well-beloved Commissioner and Servant, Lord Herbert Jobson, do hereby constitute and appoint him, the said Lord Jobson, to be our first Viceroy and Researcher in and over our said territories, and to administer the survey thereof in our name, and generally to act in our name and on our behalf, subject to such orders and regulations as he shall, from time to time, receive from us through one of our Principal Secretaries of State.

Victoria, R.I.